CINCINNATI'S
INCOMPLETE
SUBWAY

CINCINNATI'S INCOMPLETE SUBWAY

THE COMPLETE HISTORY

Jacob R. Mecklenborg

Charleston · London
The History Press

Published by The History Press
Charleston, SC 29403
www.historypress.net

Copyright © 2010 by Jacob R. Mecklenborg
All rights reserved

First published 2010

Manufactured in the United States

ISBN 978.1.59629.895.8

Library of Congress Cataloging-in-Publication Data

Mecklenborg, Jake.
Cincinnati's incomplete subway : the complete history / Jake Mecklenborg.
p. cm.
ISBN 978-1-59629-895-8
1. Subways--Ohio--Cincinnati--History. 2. Subways--Ohio--Cincinnati--Design and construction--History. 3. Local transit--Ohio--Cincinnati--History. 4. City planning--Ohio--Cincinnati--History. 5. Cincinnati (Ohio)--History. 6. Cincinnati (Ohio)--Social conditions. 7. Cincinnati (Ohio)--Economic conditions. I. Title.
HE4491.C552M43 2010
388.4'280977178--dc22
2010037826

Notice: The information in this book is true and complete to the best of our knowledge. It is offered without guarantee on the part of the author or The History Press. The author and The History Press disclaim all liability in connection with the use of this book.

All rights reserved. No part of this book may be reproduced or transmitted in any form whatsoever without prior written permission from the publisher except in the case of brief quotations embodied in critical articles and reviews.

CONTENTS

Preface	7
Acknowledgements	9
Introduction	11
1. The Deer Creek Tunnel: Precursor to the Rapid Transit Loop	21
2. Early Interurban Plans and the Supplemental Tunnel Entrance	29
3. The Canal Lease	39
4. The Arnold Report	45
5. The Edwards–Baldwin Report	53
6. Rapid Transit Loop Bond Issue Campaign and Ordinance 96-1917	65
7. Construction of Sections One through Four	75
8. Construction of Sections Five through Nine	95
9. Central Parkway	109
10. Burying the Subway	119
11. Streetcar and Freight Subway Proposals	137
12. The Millcreek Expressway	149
13. Attempts to Revive Rail Transit in Cincinnati	159
14. The Future	179
Appendix A: Canal Statement	185
Appendix B: Rapid Transit Loop Article	189
Appendix C: Timeline	197
Appendix D: Frequently Asked Questions	201
About the Author	207

Cincinnati's Incomplete Subway

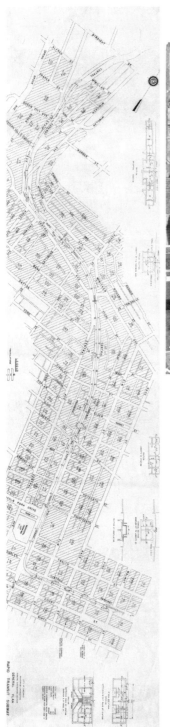

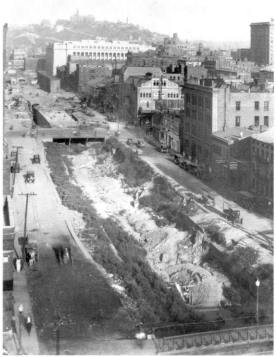

Above: Summer 1920 view of drained canal and Section One subway work. *Courtesy of the City of Cincinnati.*

Left: Circa 1951 schematic drawing of Cincinnati's Central Parkway Subway. *Courtesy of the Cincinnati Historical Society.*

PREFACE

Anomalous in the history of public transportation in the United States is Cincinnati's Rapid Transit Loop and its two-mile, never-used subway. The 1920s-era tunnel, the most significant surviving vestige of an ambitious countywide transit plan, is also a monument to the era when American cities were masters of their own fate. The Rapid Transit Loop was conceived and funded locally to reconcile a local problem; it was killed by top-down federal policy that ensured the private automobile would reign supreme in all American cities.

To understand why the subway is vilified to this day, it is appropriate to begin with a hit piece from the era in which the project was killed:

> *Not only was it built extravagantly, but the part already built is inefficient and inadequately designed. It is designed for a different gauge than our streetcar system. Even if the gauge is changed, surface cars are too light to operate at high speed in the tunnel, and subway trains are too heavy to operate on surface rails in our streets. In other words the whole thing is a "botch", which is falling into disrepair.*

The above passage, excerpted from "Rapid Transit Tunnel Is Called 'Botch,'" an article that appeared in the October 28, 1929 *Cincinnati Post*, is emblematic of the central problem that has afflicted the subway, and public transportation generally, in Cincinnati for nearly one hundred years. Every detail of the passage is at least misleading, if not entirely false. Yet it, like

Preface

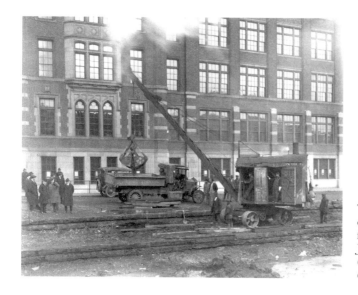

The first shovelful of dirt is lifted from the canal on January 28, 1920. *Courtesy of City of Cincinnati.*

dozens of similar articles, was printed shamelessly and unanswered in a major daily paper.

In short, the problem with Cincinnati's subway has never been its initial plan or the tunnel itself—it's been communication. Due to a lack of attention by scholars or investigative journalists, the subway's history has been told by the victors—the forces that killed the project in the late 1920s and those who have succeeded in defeating later efforts to improve the region's public transportation by invoking subway myths. As a result of these deceptions, nearly everything most Cincinnatians today know about the subway is factually and interpretively inaccurate.

The biggest misconception surrounding the subway is that its story is over. This book is merely a snapshot of the subway's first century, and by chance its writing coincided with the Rapid Transit Tubes Joint Reconstruction Project. Repairs undertaken in Spring 2010—the most significant since the tunnel was built in the early 1920s—ensure that the tunnel will remain usable for its intended purpose for generations to come. With any luck, that day will arrive in the upcoming decade, and in 2020 Cincinnatians might mark the subway's 100th birthday with a festival on Central Parkway—and then ride it home.

ACKNOWLEDGEMENTS

I wish to thank the following people who aided in researching and editing this book: John Luginbill, Rob Saley, John Schneider and the Ohio Book Store; and the librarians at the Hamilton County Law Library, the Cincinnati Historical Society Library, the Cincinnati-Hamilton County Public Library and especially Suzanne Maggard at the University of Cincinnati Archives and Rare Books Library, who directed me to much of the information and visuals contained herein that are new to the public. I also wish to thank Brad Thomas and my father, Dan Mecklenborg, for their legal advice.

I wish to thank the following people who donated photos, granted access to rooftops or who directly assisted me while taking these photographs: John Luginbill, William Cavaness, Noel Prowles, Nick Sweeney, Andy Holzhauser, Ronny Solerno, Nick Guerry, John Schneider and helicopter pilot Dan Kelly.

INTRODUCTION

Any discussion of Cincinnati's failed subway project must begin with a brief recount of the city's local characteristics and nineteenth-century development, which necessarily begin with a description of the contour of the Ohio River's northern bank. Whereas other river towns occasionally became part of the river, the "upper alluvial plain"—a geologic oddity stretching between today's Fourth Street and the base of Mount Auburn—gave Cincinnati a decisive advantage over similarly inauspicious frontier settlements along the Ohio. This natural rise motivated construction of Fort Washington; protection from both floods and natives made Cincinnati America's first western boom town.

But by 1850, when Cincinnati nearly surpassed both Boston and Philadelphia in population, its industry and poor residents sprawled onto the "lower alluvial plain," the larger areas of flat land that surround the upper flood plain on three sides. With the city boxed in by hills and having almost no available flood-proof sites available for industry, after the Civil War investors shifted their attention to fledgling St. Louis and Chicago. European immigrants followed, ending Cincinnati's fifty-year run as America's leading inland city.

Expanses of flat and flood-proof land five miles north of Cincinnati were made accessible by the appearance of electric streetcars in the late 1880s, but long streetcar rides tested the patience of riders and were inherently unprofitable; the Cincinnati Street Railway was limited by law to charge five cents per passenger, no matter how long the route. But in 1912, a plan

Introduction

appeared that promised to solve all of these problems: A sixteen-mile rapid transit beltway utilizing the city's obsolete canal, unpopulated hillsides and ravines would enable large-scale development of the interior of Hamilton County and give the city of Cincinnati leverage in its efforts to annex new industrial and residential areas. In addition, the beltway would provide entry to the old city for the county's nine interurban railroads, which, since their inceptions, had been relegated to ignominious and unprofitable terminals on the city's periphery.

The beltway plan, defined legally as the Cincinnati Rapid Transit and Interurban Railway, but known popularly as "The Rapid Transit Loop," was both logistically and politically brilliant: The circumferential route was not only equitable to nearly all parts of the city, it also promised to be the least expensive American rapid transit project, per foot, of the prewar era. The merits of the plan were so self-evident that the electorate—by a margin of 6–1—approved a $6 million bond issue for its construction in 1916. But the Rapid Transit Loop had the terrible misfortune of being built under financial, cultural and political conditions so rapidly and radically changed from those in which it was conceived and funded as to only be considered fairly, in their aggregate, to be an act of God.

Those who prevented a supplementary bond issue from being presented to the electorate in the late 1920s pointed to the city's limited borrowing power; however,

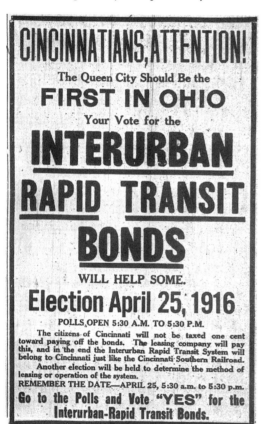

The Rapid Transit Loop's $6 million bond issue passed by a 6–1 margin in 1916, and its lease to the Cincinnati Street Railway passed by a 2–1 margin in 1917. World War I delayed construction until 1920. *Courtesy of the* Cincinnati Commercial-Tribune.

INTRODUCTION

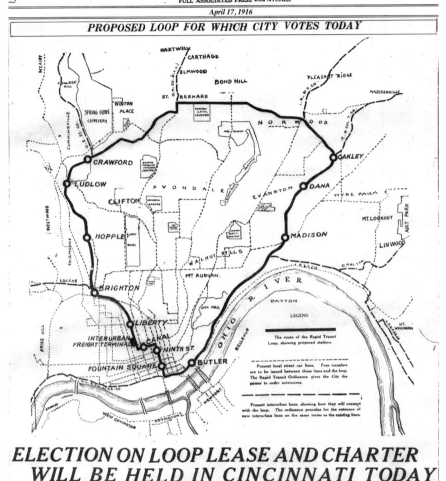

The economic effects of World War I doubled materials costs and the $6 million bond issue approved in 1916 was inadequate to build the Rapid Transit Loop "Modification H" plan *Courtesy of the* Cincinnati Commercial-Tribune.

records documented in this book illustrate that Cincinnati not only had the financial ability to complete and operate the line, but also was, by the mid-1930s, the least indebted city of its size in the United States. City finances during this period were bolstered by income from the Cincinnati Southern Railroad, whose lessee paid increased rental beginning in 1928. Instead of

Introduction

being directed toward completion of the Rapid Transit Loop, these railroad proceeds instead paved city streets and in the 1950s partly financed the loop's replacement by the Millcreek Expressway.

Whereas this mid-1920s policy shift toward the public financing of automobile infrastructure by all levels of government caused St. Louis, Pittsburgh, and Detroit and other cities to shelve their subway plans, Cincinnati's line was already under construction, and in the face of "free" state and federal money for roads, it needed stable political support in order to ensure funding for its completion. But instead of receiving such support, its period of construction overlapped the ouster of Boss Cox's decades-old Republican Machine by a group of young Republicans, led by Murray Seasongood and known as the Charterites.

During their rise and initial years in power, Seasongood and the Charterites did not just attack the administration of the project by the machine-controlled Rapid Transit Commission, but they also spread misinformation regarding the subway's physical character and inserted doubt about the line's utility into the public consciousness. Upon taking the mayor's seat in January 1926, Seasongood picked a fight with the Rapid Transit Commission and shifted public interest away from the Rapid Transit Loop, which remained under construction until its 1916 bond issue was exhausted in 1927, to proposals for short streetcar subways in the downtown area. He had no intention of leading efforts to build these new tunnels; instead, they were devised as distractions to argue that the existing rapid transit subway was the wrong type of subway and in the wrong place.

After the Rapid Transit Commission was dissolved and Seasongood left local government in 1930, politicians of all stripes who succeeded the first generation of Charterites were forced to answer the public's constant questions about the two dozen unused overpasses and underpasses that could be seen throughout the city and, of course, the unused subway tunnel. The public's questions were answered by a continuation of Seasongood's strategy: mischaracterization of what existed and what possibilities the line afforded, exaggeration of capital and operational expenses and prioritization projects deemed to be of greater importance, especially road projects.

After World War II, the Rapid Transit Loop's surface right of way was, along with much of the city's densely populated West End, placed on a collision course with Interstate 75's bulldozers. Because the two-mile subway tunnel beneath Central Parkway would be marooned by highway construction, the era's politicians, a generation removed from those who

INTRODUCTION

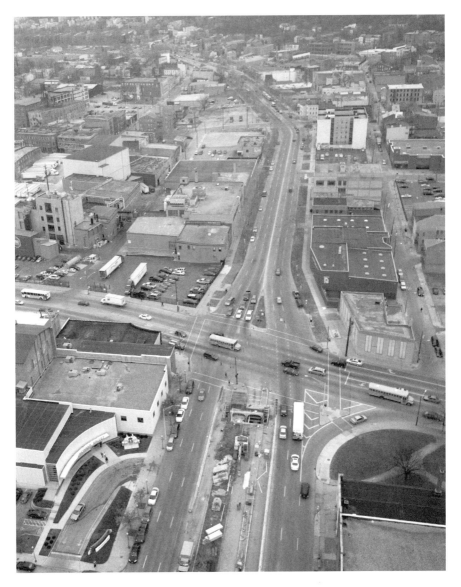

View of temporary access point south of Liberty Street created as part of the 2010 Rapid Transit Tubes Joint Replacement Project. *Courtesy of the author.*

built the subway, concocted a scheme to make the tunnel disappear and justify its nonuse to the public.

The tunnel, which was built to accommodate freight trains and whose dimensions nearly meet the specifications of twenty-first century "Plate B"

INTRODUCTION

Sections of the subway's roof were removed in February 2010 to permit the lowering of equipment into the tunnel. *Courtesy of the author.*

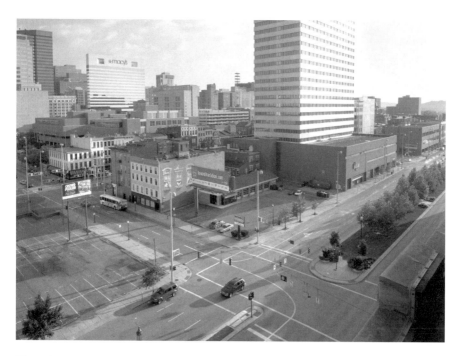

View of the intersection of Central Parkway and Walnut Street. The subway ends at this point, a half mile from Fountain Square. *Courtesy of the author.*

Introduction

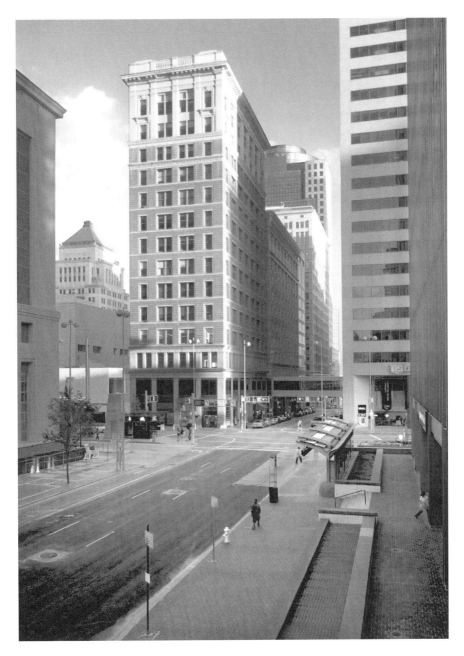

It is here at the intersection of Walnut and Fifth Street where the Rapid Transit Loop's Fountain Square station was to be built. Nearly half of the loop's seventy thousand daily riders were to have used this station. *Courtesy of the author.*

INTRODUCTION

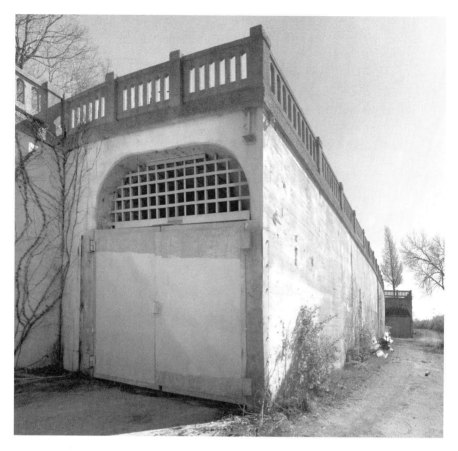

These portal doors, the subway's most conspicuous feature, were built 1926–1927 as part of the Central Parkway project. Originally, the subway surfaced about one thousand feet south of this point near the Brighton Bridge. *Courtesy of the author.*

loading gauges, was declared too small for the freight equipment of the 1940s after two dozen industries sought its use for freight deliveries. This outright lie was bought by the public and evolved into the preposterous rumor still heard in barbershops sixty years later—that the subway was never used because the subway cars didn't fit.

Unfortunately, instead of reviving the Rapid Transit Loop in the 1950s for the great suburban boom that it anticipated, no provision was made for rapid transit trains to operate in the median or alongside the new expressways that came to replace nearly all of the loop's completed surface sections and a never-built eastern section. Hamilton County and exurban counties have since developed entirely around the physics of the automobile.

Introduction

Meanwhile, the old city—Cincinnati was and in some areas still is one of the few American cities with genuine European old-world charm—ate itself alive as countless nineteenth-century homes and commercial buildings were felled for wider roads, expressways, parking lots, parking garages, strip malls, gas stations and fast-food restaurants.

The highway boom was made possible by an embedded state- and federal-funding structure—never approved directly by the electorate—that tipped the scales dramatically in favor of the private automobile. Significant federal allocations for local transit projects did not begin until 1970, at which point the majority of the Interstate Highway System had been built. Even then, eligibility for federal awards required local matches that could not be met by midsize cities without tax levies. Such levies were defeated in Hamilton County in 1971, 1979, 1980 and 2002. Each of those taxes could have or was explicitly planned to fund local matches for federal awards that would have seen the old subway tunnel activated as part of a countywide rail transit network.

The future of the subway, and what role it might play as part of a regional transit network, is discussed in this book's final chapter. Although the old tunnel might not be incorporated into such a system, I believe that this book will help clear the fog surrounding the subject, and in so doing remove the subway's construction and nonuse as a dependable "argument" of antirail, anticity forces.

Chapter 1

THE DEER CREEK TUNNEL

PRECURSOR TO THE RAPID TRANSIT LOOP

The Deer Creek Tunnel, partially constructed between 1852 and 1855, is arguably Cincinnati's greatest failed project. As much as Cincinnati and suburban Hamilton County's twenty-first-century form is characterized by the absence of the Rapid Transit Loop and its never-used subway, the region's development has been shaped even more by the abandonment of this lesser-known tunnel deep beneath Walnut Hills. Relevant to the primary subject of this book, completion of the tunnel would have resolved the issues revisited by Rapid Transit Loop seventy years later: the need for a rapid transit connection between Cincinnati's basin and central Hamilton County and a city entrance for various electric interurban railroads.

The Deer Creek tunnel, also known as Kemper's Hill Tunnel, was the central feature of the Cincinnati & Dayton Tunnel Short Line, chartered in 1847, which promised to be the equivalent of an interstate highway in an era of primitive iron-rail railroads. The immediate business plan of the Cincinnati & Dayton concerned construction of an enormous nine-thousand-foot double-track tunnel and its rental to a variety of existing or planned railroads. At full build-out, its superior route between the railroad's namesake cities promised to capture the business of the circuitous and flood-prone Cincinnati, Hamilton and Dayton Railroad and send it into bankruptcy.

In addition to track rental, a significant part of the company's plan involved the development of a large new neighborhood in the farmland immediately north of the Avondale portal, likely platted to either side of

CINCINNATI'S INCOMPLETE SUBWAY

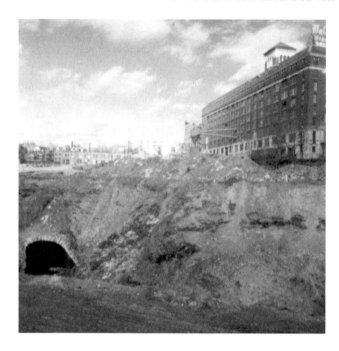

The Deer Creek Tunnel was exposed in 1966 during construction of Interstate 71. *Courtesy of the Cincinnati Historical Society.*

today's Victory Parkway. With trains achieving speeds of forty miles per hour or more in the tunnel, this new neighborhood would be situated within five minutes of downtown Cincinnati. Unlike the wealthy village of Glendale on the rival CH&D line, these lots would be marketed to the middle class, who the railroad anticipated would abandon the basin in large numbers for "little homes beyond the hills."

Unfortunately, construction ceased in 1855 after 2,000 to 3,336 feet (accounts vary wildly) of tunnel were completed and $425,000 exhausted. A primary cause for the work stoppage was the inability of the recently chartered Cincinnati, Lebanon and Xenia Railroad to raise necessary funds for its construction south from Warren County to the tunnel's north portal. The completion of the CL&X—in a mirror of what the Cincinnati & Dayton and its tunnel portended for the CH&D—promised to bankrupt the Little Miami Railroad.

Here, the financial dilemma of the Deer Creek Tunnel comes to a head. Although it was plain to see that the tunnel was in the city's best long-term interest, many area residents already owned stock in the existing CH&D and Little Miami and therefore had no motivation to support a project that would certainly undermine earlier investments. Further, those whose property would be devalued by a radical shifting of the city's primary rail

The Deer Creek Tunnel

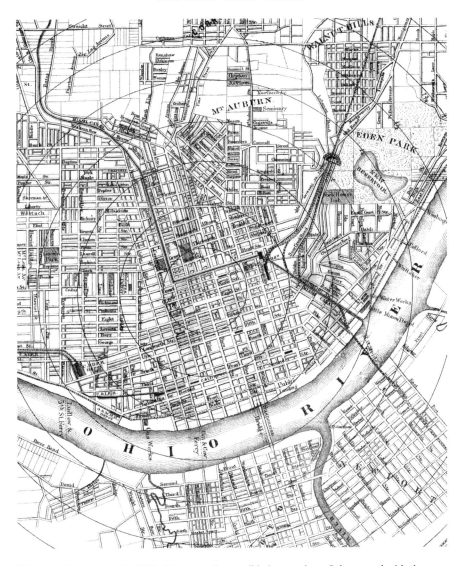

This map from the early 1870s illustrates the possible integration of the tunnel with the Little Miami Railroad's Eggleston Avenue tracks and the potential for a crosstown link via the canal. *Courtesy of the Cincinnati Historical Society.*

approaches fought the tunnel at every stage of planning and construction and then fought its various revival attempts.

The tunnel met further competition for local capital when calls were made on the stock subscriptions of the Covington and Cincinnati Bridge Company in July 1856. Despite the "Ohio Bridge" being the longest bridge

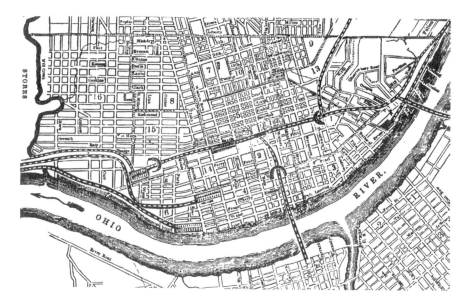

1850s-era plan for a railroad tunnel under Sixth Street linking the Cincinnati & Dayton with Mill Creek railroads. *Courtesy of the Railroad Record.*

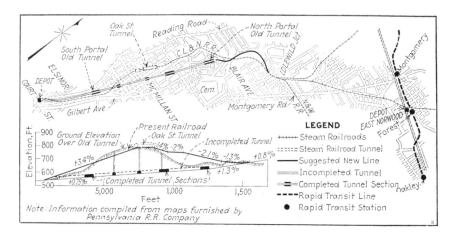

Completion of the Deer Creek Tunnel was last studied in 1927. *Courtesy of the Beeler Organization, Report to the City of Cincinnati.*

in the world, what we know today as the John A. Roebling Suspension Bridge was a somewhat smaller project than the Deer Creek Tunnel. About $300,000 was spent on the bridge and $425,000 on the tunnel before attempted revivals of both were extinguished by the Panic of 1857. Delay in

The Deer Creek Tunnel

reorganization of the Cincinnati and Dayton Railroad after the Civil War was caused in part by the attraction of significant additional local capital to the suspension bridge, which resumed construction during the war in 1863 and opened in January 1867.

The unfinished tunnel's competitive advantages were further eroded when areas of Avondale and Norwood were developed in the 1880s after operations commenced on the Cincinnati, Lebanon & Northern, a narrow-gauge line built on parts of the CL&X's completed right of way north of Cincinnati. Its approach to the city passed within eyesight of each of the Deer Creek's portals, but its utility as a commuter railroad was hindered by its steep climb and single-track operation through its own short tunnel; it nevertheless initiated development of the area where the Cincinnati & Dayton had hoped to profit by development of a major suburb.

With that source of income eliminated, the profit motive for the privately financed completion of the Deer Creek Tunnel weakened. Public financing for completion of the tunnel was out of the question; city finances were strained to the breaking point after Cincinnati Southern Railroad bonds were sold in 1869. Completion of the tunnel was last considered in 1927 for use by rapid transit and interurban trains as an alternative to the originally planned eastern section of the Rapid Transit Loop.

The Tunnel Rediscovered

The CL&N was obligated, as a condition of its charter, to fill the Deer Creek Valley to the level of Gilbert Avenue. Accomplishment of this task took about fifteen years and was intended to both ease movement across the sharply sloped valley and to prepare it for development. This activity buried the Deer Creek Tunnel's south portal in or around 1900, setting the stage for its periodic accidental rediscoveries.

The tunnel experienced its first cave-in in 1916, when a hole opened in a playing field at Deer Creek Common, a park built on part of the CL&N's fill. It was reported at that time that the tunnel was accessible to workmen through a sewer built to keep it dry after it was covered over. Another part of the tunnel roof collapsed nearby in 1944, with similar results. In 1951, use of the tunnel as a bomb shelter was proposed, but no action was taken.

In 1966, the south section of the tunnel was uncovered during construction of Interstate 71. It was reported that the tunnel was filled with water, indicating that the old sewer had been blocked or damaged. Many believed

that this part of the tunnel was filled permanently during expressway construction, but that was proven false in November 2007, when the tunnel made its presence known once more during construction of a new hotel at the corner of Florence Avenue and Eden Park Drive.

In an exchange of e-mails with the author, William Cavaness of Baker Concrete detailed the incident:

> When the rear of the trackhoe fell in the counterweight wedged against the back wall and the track that you can see was wedged at the edge of solid ground. The settling of the trackhoe happened overnight. Normally we didn't park it there but the tracks needed cleaning and the person that cleaned them did not return the trackhoe to the gravel parking area. When I arrived the next morning I thought he had left the bucket hanging in the air which was an OHSA violation and was going to say something to him about it. It was foggy that morning, so as I got close enough I realized the hoe had sunk. The foreman asked if I could get it out and I said no problem. After the fog cleared and I could see into the hole I quickly changed my mind and informed the foreman of the extent of the hole. If I remember the hole was around 17ft deep. Over the next couple of days while we waited on a solution the hoe continued to sink…I was told the hoe was wedged so bad the 500 ton crane could barely remove it.
>
> Then approximately 200 to 250 cubic yards of control density fill was poured in to the opening until full. We ran into the tunnel a little farther south but built a ramp to the bottom and used engineered fill to bring the rest of the tunnel up to grade. Nothing too exciting. We tried to take more pictures of the tunnel but it was too dangerous.

What Might Have Been

Cincinnati's nineteenth-century history is dotted by a fascinating series of what ifs. At a relatively early stage in the city's history, the nearly two-mile-long Deer Creek Tunnel promised to direct the city's subsequent development on a course so profoundly different as to have made it largely unrecognizable to those who today call it home. Most of the great landmarks familiar to Cincinnatians today would have taken another form, not the least of which being Union Terminal, as a union station would almost certainly have been built decades earlier in place of the canal or on Cincinnati's riverfront.

With the flat lands of central Hamilton County opened to industrial

The Deer Creek Tunnel

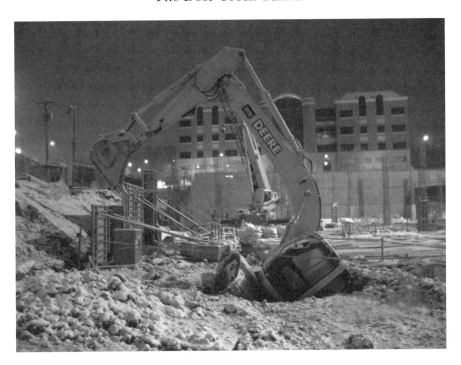

A track hoe fell partially into the tunnel during construction of the Spring Hill Suites Hotel parking garage, December 2007. *Courtesy of William Cavaness.*

development before the inevitable shift of speculative capital to St. Louis and Chicago, Cincinnati could have captured some of the industry and population that instead took root farther west. Meanwhile, with less population density in the old city, Over-the-Rhine might have retained some of its pre-Civil War character, which was lost when the neighborhood was almost completely rebuilt as three- and four-story row buildings similar to those in New York City in the 1870s and 1880s.

The tunnel might also have reduced the loss of population to Covington and Newport, where growing numbers commuted to or from workplaces on both sides of the river via the Roebling Suspension Bridge or ferryboat. In 1873, the *Cincinnati Enquirer*, indicating that hopes for the tunnel's completion were still alive, declared that "the completion of the Walnut Hills Tunnel and the establishment of a rapid transit line of railway to the country beyond the hills will give new life…as soon as this tunnel is finished the problem of Cincinnati's future will be solved…our population, instead of working over to Covington and Newport, will be kept within our own demesnes."

Chapter 2

EARLY INTERURBAN PLANS AND THE SUPPLEMENTAL TUNNEL ENTRANCE

The failure of the Deer Creek Tunnel meant Cincinnati's rail entanglement devolved in the nineteenth century's closing decades into the worst such situation in the United States. Then, with the appearance of nearly a dozen new electric interurban railroads between 1900 and 1907—all of them forced to terminate miles from the city center or travel over the tracks of the Cincinnati Street Railway—the situation grew even worse.

Intelligent men recognized that a solution to the new and overlapping problem created by the interurbans could play a much more lucrative role as part of a riverfront union station. Borrowing from the business plan of the defunct Cincinnati & Dayton and its unfinished Deer Creek Tunnel, a six-mile line between Norwood and the basin via Walnut Hills or O'Bryonville would create a high-speed entrance for electric interurban railroads and a superior approach for existing steam passenger trains. Either route would inevitably necessitate a tunnel, but one just a quarter the size of the abandoned Deer Creek Tunnel.

The first man to act on this opportunity was Jacob Schmidlapp, a prominent figure in Cincinnati's business community who built his fortune in tobacco and whiskey wholesaling, warehousing and real estate development before chartering the Union Savings Bank & Trust Company. After his wife and daughter died in a train wreck outside Kansas City in 1900, he spent the remainder of his life giving his money away, with an emphasis on improving the housing conditions of Cincinnati's poor.

Cincinnati's Incomplete Subway

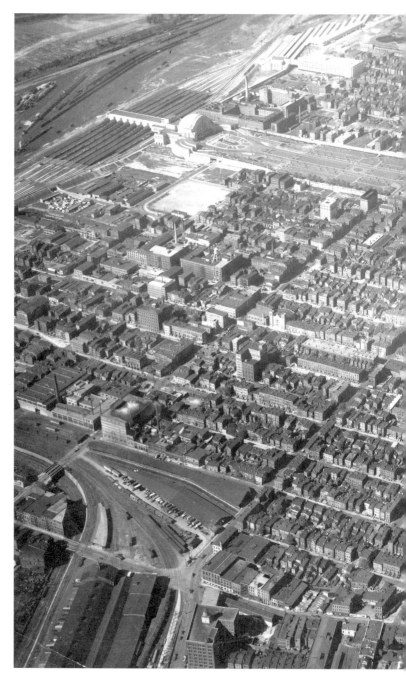

This circa-1935 aerial view of the West End illustrates the hellish overcrowding of Cincinnati's basin; for much of the nineteenth century, it was the most densely populated area in the United States outside New

Early Interurban Plans and the Supplemental Tunnel Entrance

York City. Central Parkway and the subway are visible in the top-right corner of this photograph. *Courtesy of the Cincinnati Historical Society.*

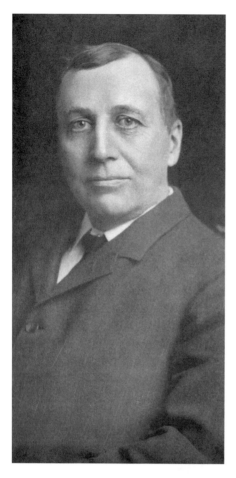

Portrait of Jacob Schmidlapp. *Courtesy of University of Cincinnati Archives & Rare Books.*

Schmidlapp knew that an interurban-only approach would not repay its construction cost, and although a riverfront union station promised boundless profits for the exact same six-mile railroad, such a station was not a certainty. However, he believed that interurban railroads offered a solution for Cincinnati's greatest social problem—overcrowding of basin tenements—and argued that a rapid commuter service on the interurban entrance he proposed would enable new middle-class suburbs in Norwood and beyond. The vacancies left in the basin's old row buildings would allow the poor to occupy larger spaces in existing buildings and excess buildings could be demolished for park space. He hired his own surveyor, spent years promoting his plan and even offered to invest an unspecified amount of his own money.

The business community and the city, for reasons that are not entirely clear, did not align themselves with his plan. After the Union Depot & Terminal Company's plan was announced in 1910, Schmidlapp made a point of reminding all that he devised and promoted a similar plan to their "Supplemental Tunnel Route" nearly a decade earlier. The existence of such a railroad by 1910 would have simplified the planning of a riverfront union station and earned tremendous rental fees for whichever individual, company or municipality happened to own it.

The only interurban railroad that made public extravagant entrance plans on its own accord was the Ohio Electric Company, which consolidated a vast network of interurban lines throughout the Midwest under its name in 1907. It studied basin entrances for both of its Cincinnati-area lines,

Early Interurban Plans and the Supplemental Tunnel Entrance

Tunnels beneath the O'Bryonville business district were planned as part of the the Supplemental Tunnel Route and Rapid Transit Loop. *Courtesy of the author.*

each terminating on Chicago-style elevated viaducts above Cincinnati's downtown streets. Its Springfield Pike, or "Mill Creek Valley Line," was planned to approach the city along a Norwood route similar to Schmidlapp's railroad and the later Supplemental Tunnel Route. Its College Hill approach proposal was the more interesting of the two, involving a tunnel under Clifton and another in Walnut Hills.

THE UNION DEPOT & TERMINAL COMPANY

In 1910, fifteen years before the region's railroads chose a West End site and built Cincinnati's spectacular Union Terminal, the city granted a franchise for an even more ambitious union station plan on the city's riverfront. The Union Depot & Terminal Company, headed by New York financier John Bleekman and backed by J.P. Morgan, worked to construct a huge elevated station where all intercity passenger trains and electric interurbans would converge within walking distance of Fountain Square.

Adjusted for inflation, its estimated $36 million cost dwarfed the eventual $44 million cost of Union Terminal, and the Union Depot & Terminal

UNION STATION PLANS MADE PUBLIC.

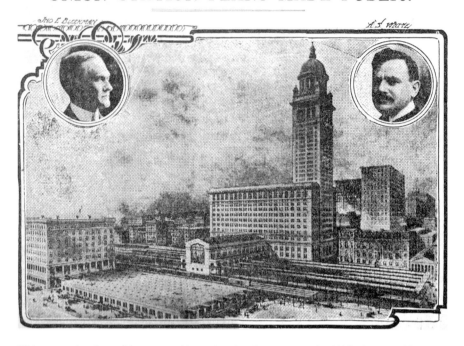

This promotional graphic appeared in various local newspapers in 1910. *Courtesy of the Cincinnati Times-Star.*

Company sought to recoup construction costs and eventually realize a profit with a variety of side businesses. A five-hundred-foot office tower above the station head house and acres of warehouse space beneath its elevated station tracks promised steady income, but a critical part of the plan, known as the Supplemental Tunnel Route, revisited Schmidlapp's earlier interurban entrance plan.

The original $6 million Supplemental Tunnel Route plan featured two four-track tunnels: one under Owl's Nest Park and Madison Road in O'Bryonville and another under Mount Adams. In later proposals, this tunnel was eliminated in favor of a longer surface route around the south base of the hill. Changes such as this, and those in Norwood and O'Bryonville, might have been orchestrated to mislead land speculators, and all along, the Union Depot & Terminal Company might have in fact planned to use Schmidlapp's route.

Early Interurban Plans and the Supplemental Tunnel Entrance

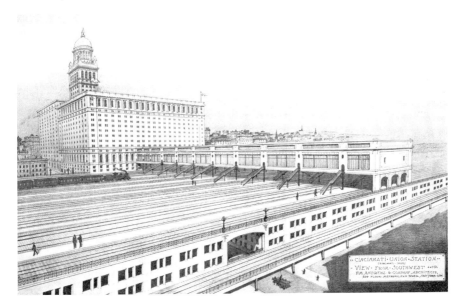

The Union Depot & Terminal was planned for the land presently occupied by Fort Washington Way. *Courtesy of the* 1910 *Report of the Union Depot & Terminal Company.*

A circa 1905 view of the East End from Eden Park. The Supplemental Tunnel Route was to have hugged the hillside above the Little Miami Railroad and turned north at Torrence Ravine, visible at top center. Later, the Rapid Transit Loop's eastern routing was planned to follow the same path. *Courtesy of the University of Cincinnati Archives & Rare Books.*

The Supplemental Tunnel Route and its relationship with area railroads. *Courtesy of the Cincinnati Union Depot & Terminal Company.*

Public Financing and Ownership of the Canal Subway and Supplemental Tunnel Route

The chronological overlap of the Union Depot & Terminal Company's 1910 and 1912 franchises, the 1911 canal lease and the Arnold Report of 1912 indicate that, for several years, an epic battle involving the railroads and Cincinnati's prominent citizens raged behind the scenes. The Union Depot

Early Interurban Plans and the Supplemental Tunnel Entrance

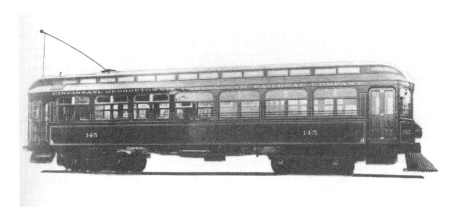

Typical interurban car. *Courtesy of the Noel Prowles Collection.*

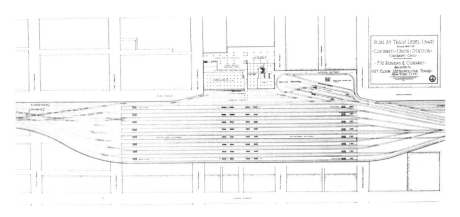

This schematic illustrates one interurban terminal plan made public by the Union Depot & Terminal Company. *Courtesy of the Cincinnati Union Depot & Terminal Company.*

& Terminal Company's own publications, including its 1912 report, made explicit mention of the unavailability of the Miami–Erie Canal, despite the state having recently granted a lease for railroad purposes. Meanwhile, the contemporaneous Arnold Report avoided consideration of the Union Depot & Terminal Company plan, other than a casual mention of the Supplemental Tunnel Route, but called "The Bleekman Plan."

To fill the company's financing gap, mention of public financing was periodically voiced. But instead of financing the station itself, it appears that forces acting on behalf of the City of Cincinnati hatched the Rapid Transit Loop plan—which was advertised as a combined interurban entrance and

rapid transit railway—to place both remaining practical railroad entrances under city control. Track rental from the two approaches was of keen interest to the era's corrupt Republican political machine; like the annual rental generated by the Cincinnati Southern Railroad, such income beyond the state-limited 10-mill property tax, street railway franchise payments and typical fees and fines could fuel the machine's patronage.

CHAPTER 3

THE CANAL LEASE

The interurban entrance schemes proposed in the new century's first decade by Jacob Schmidlapp, the Ohio Electric Company and the Union Depot & Terminal Company largely ignored the Miami–Erie Canal, whose eventual availability for use by any type of railroad was uncertain. They knew that any mention of constructing a railroad in place of the obsolete canal could turn public sentiment against the remainder of any proposal—a result of the disastrous logistical and legal conditions created by the laying of railroad tracks in the center of Eggleston Avenue.

Originally a series of locks connecting the canal's turnaround pool with the Ohio River, Eggleston Avenue was, by the time the Rapid Transit Loop was conceived, a mess of railroad tracks on state property over which the City of Cincinnati collected no revenue and exerted no control. Rail activity on this short spur blocked pedestrian, horse and streetcar traffic between downtown, Mount Adams and the East End, and the lease of the remainder of the canal within city limits under similarly loose terms promised the spread of this situation to the city's most densely populated sections.

This strange arrangement arose due to a sequence of events described in 1913 by George Barch, President for the Association for the Improvement of the Canal:

> *In 1863 the Ohio Legislature passed an act granting the canal bed between Broadway and the river to the city of Cincinnati for highway purposes… Afterwards the Little Miami Railway, by consent of the city, constructed a*

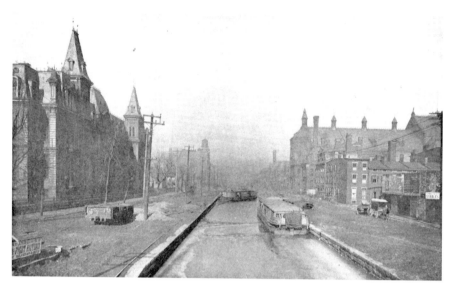

The Miami–Erie Canal, looking north from the Twelfth Street Bridge circa 1900. The City Hospital is visible at left. *Courtesy of George Kessler's 1907* A Park System for Cincinnati, OH.

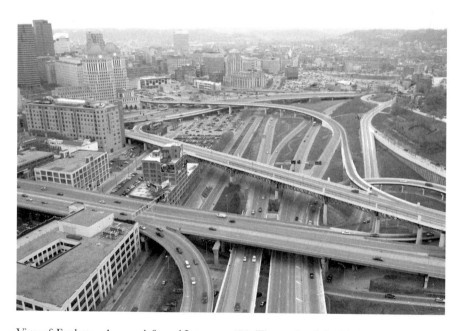

View of Eggleston Avenue, left, and Interstate 471. The tracks of the Little Miami Railroad replaced the canal's Ohio River locks in the center of Eggleston Avenue. *Courtesy of the author.*

The Canal Lease

steam railroad track on that part of Eggleston avenue that had formerly been the canal bed. The result was that the Supreme Court of Ohio decided that Eggleston Avenue as was within the limits of the old canal was therefore forfeited to the state of Ohio by reason of violation of the terms of the grant in allowing the railroad company to use the ground for railroad purposes, even though the city of Cincinnati had spent nearly a million dollars in filling and paving the entire avenue, with our filling and paving, belongs to the stat of Ohio which rents it to the Pennsylvania Railroad.

With this history, it is easy to understand city opposition to an exotic 1883 request by the Cincinnati Northern Railroad to construct a steel viaduct directly over several miles of the canal. The City of Cincinnati had no jurisdiction over the canal or parcels of land to either side (legally defined as "canal lands") but was able to stop the plan by denying Cincinnati Northern's request to construct an extension of its canal viaduct over city streets en route to an elevated terminal station at Government Square.

Drawings of the canal replaced by a Parisian boulevard and underground railroad first appeared in the 1880s. *Courtesy of the* Graphic.

At that early date, Cincinnatians made it known that any redevelopment of the remainder of the Miami–Erie Canal must ensure a favorable aesthetic outcome; sketches of an underground railroad capped by a Parisian boulevard first appeared in local publications soon thereafter. Such a tunnel was impractical in the steam era, but after construction of the country's first electric rapid transit subway in New York City and electrification of Grand Central Station, Cincinnatians were at last willing to consider the canal's redevelopment.

Meanwhile, there were from the 1850s onward continuous calls for expansion of Ohio's two cross-state canals. Miami–Erie Canal expansion schemes were typically paired with proposals for construction of an artificial Ohio River harbor where the Queensgate railroad yard is now located. The harbor facility would have been created by a lock and dam near the mouth of the Mill Creek and would have connected with the widened and deepened Miami–Erie Canal near the present location of today's Interstate 75/74 interchange. Later plans would have used a dammed and straightened

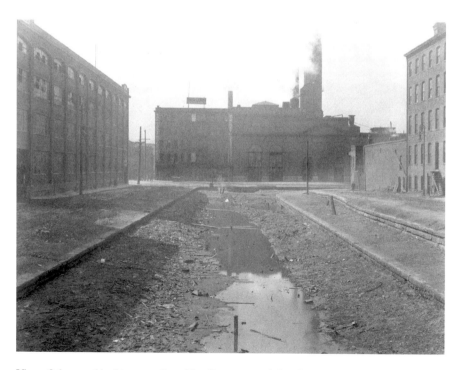

View of the canal looking west from Elm Street toward the elbow. The powerhouse visible at center used canal water until early 1920, delaying work on Section Two. *Courtesy of the City of Cincinnati.*

The Canal Lease

This spillway, built in 1922 north of St. Bernard, diverted canal water into the Mill Creek. *Courtesy of the City of Cincinnati.*

Mill Creek in place of the canal north of St. Bernard. Aside from providing an area safe from river currents for the transfer of cargo, the harbor would also have created a refuge for towboats and barges from winter ice flows. Proposals for barge and ship canals continued into the 1950s and 1960s, but by then involved canalization of the Great Miami River.

LEASE CONDITIONS

Convinced that its contemplated cross-state canal expansion project, if built, would inevitably utilize the Mill Creek through Cincinnati, in 1911, the Ohio state legislature passed Senate Bill no. 259, permitting the City of Cincinnati to lease the canal for $32,000 annually between its downtown terminus and the city's northern corporation line just north of Mitchell Avenue. Construction of a railroad tunnel beneath the boulevard was an optional condition of the lease, but if built, its use by steam locomotives was prohibited except in case of "emergencies." A revision to the lease permitted the construction of vents in the subway's roof, ostensibly to mitigate the "piston-action" of air

pushed ahead of speeding electric subway trains. However, these vents were in fact built in order to permit the regular operation of steam locomotives in the canal subway. What specific role the tunnel would eventually play in the city's passenger and freight railroad network was not determined prior to or even during subway construction. In 1922, while the subway was being built, *Popular Mechanics* reported, "In order to admit freight cars, if necessary, the tubes have been built with a clearance of 14 feet 9 inches over the top of the rail."

If it had been the intention of state politicians to prevent the tunnel's eventual usage by mainline passenger and freight trains pulled by steam locomotives, they could have mandated a low tunnel ceiling that would have prevented the use of standard equipment. This detail is a critical part of the subway's story: standard subway trains are shorter than standard box cars, and the twelve foot, six inch "Assumed Car for the Belt Line" detailed in the 1914 Edwards–Baldwin Report would have enjoyed over two feet of vertical clearance. But beginning in the late 1920s, those forces acting to kill the subway rewrote its history and convinced the public that the tunnel was unusable due to its incompatibility with a variety of equipment. The nature of the irresolvable problem shifted depending on whom was describing it, but usually subway foes claimed that the tunnel dimensions were "too small" and trains "couldn't make the curves."

CHAPTER 4

THE ARNOLD REPORT

Opposition to the lease and redevelopment of the canal, with the exception of a small number of manufacturers who drew water from the canal, was minimal. With the signatures of Governor Judson Harmon and Cincinnati mayor Henry Hunt, on August 29, 1912—fifteen months after passage of Senate Bill no. 259—the City of Cincinnati entered into a ninety-nine-year lease of the canal from the State of Ohio. Arbitrators determined the value of the canal to be $800,000 and payments were to be made in installments of $16,000 every October 1 and April 1.

In anticipation of the lease, on March 26, 1912, Cincinnati City Council authorized formation of the Interurban Rapid Transit Commission to "suggest ways and means of securing high-speed interurban electric railway service." This commission and its subcommittees were comprised of men with names still prominent one hundred years later—Proctor, Shillito, Nippert, etc.—who were some of the most successful and serious local businessmen of their day. Notably absent from this group, and all but proving that the local business community was acting to kill riverfront union station plans, were the trustees of the Union Depot & Terminal Company. Also conspicuous in his absence was Jacob Schmidlapp, who opposed the canal subway and boulevard plan on the grounds that it was too expensive and would divert scarce public funds from the less expensive but more functionally important eastern interurban entrance.

With $10,320 in private contributions, the new commission hired Bion J. Arnold, the country's preeminent electric railroad consultant, to

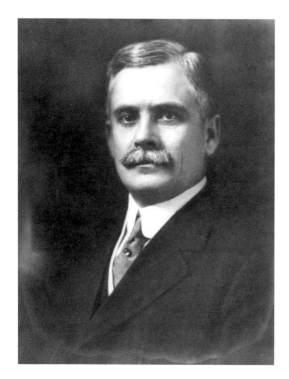

Bion J. Arnold was the era's preeminent electric railroad consultant. He designed the first commercial use of an electrified third rail in Chicago in 1893 and designed the electrification of New York's Grand Central Station ten years later. *Courtesy of the Noel Prowles Collection.*

combine the canal subway and Supplemental Tunnel Route into one all-encompassing project. Arnold's two-hundred-page report, dated October 21, 1912 (just three weeks after Cincinnati made its first $16,000 canal-lease payment), included a general description of Cincinnati's physical layout, the whereabouts and character of each of Hamilton County's nine interurban railroads and spreadsheets listing their ridership and finances. Upon this background information, he outlined a $13,000,000 plan, small by the scale of the New York and Chicago projects he was accustomed to but incredibly ambitious for a city of Cincinnati's size.

Arnold's Beltline and Subway Proposals

Two great anonymous minds preceded Arnold: whoever first recognized that the canal and proposed Supplemental Tunnel Route and canal nearly met in Bond Hill and whoever recognized that a beltline combining the two could win at the polls. It was Arnold's job to estimate the cost and give professional credibility to the beltline concept; however, the emphasis of his

The Arnold Report

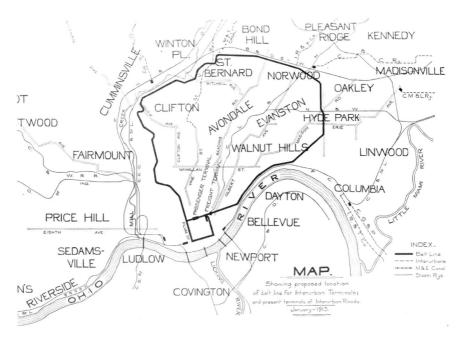

The Arnold Beltway Map includes the O'Bryonville–Hyde Park Tunnel and Edwards Road alignment. *Courtesy of the Arnold Report.*

"Report on an Interurban Electric Railway Terminal System for Cincinnati" on the "interurban problem" thinly cloaked its ulterior purposes: to perform preliminary rapid transit estimates and to disrupt the plans of the Union Depot & Terminal Company.

The cavernous, six-track underground freight terminal described in the report's first section was more likely a preliminary estimate for an underground union station. Proposed later in the report, this terminal location in place of the canal could be reached on a straight alignment by the $1 million Mount Adams Tunnel, which also connected to the Supplemental Tunnel Route. Access to the freight terminal's west side was by way of a four-track subway in the canal, two miles north to Queen City Avenue. Such overbuilding indicates either that much grander plans were afoot or that these features were intended to intimidate opponents and confuse speculators.

Another outsized concept discussed in the Arnold Report is a downtown subway loop. This was the first of many downtown loops that were outlined in rapid transit, streetcar and trolleybus subway reports through the late 1940s. Arnold also proposed a $1.1 million mile-long tunnel between O'Bryonville

Cincinnati's Incomplete Subway

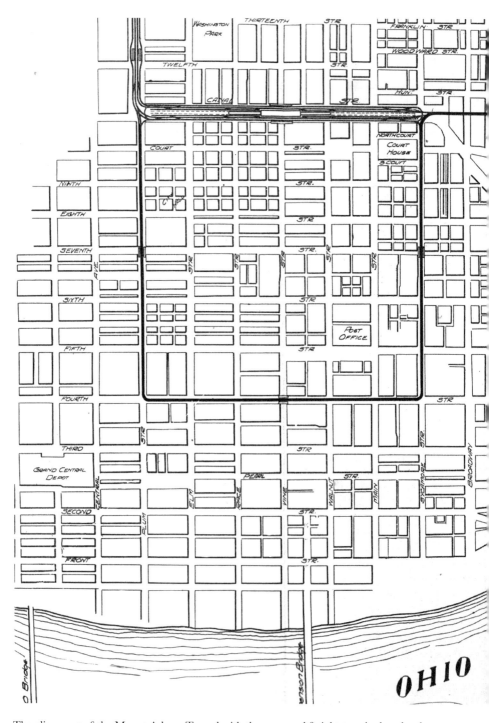

The alignment of the Mount Adams Tunnel with the proposed freight terminal under the canal between Plum and Broadway illustrates how this feature of the Arnold Report was a

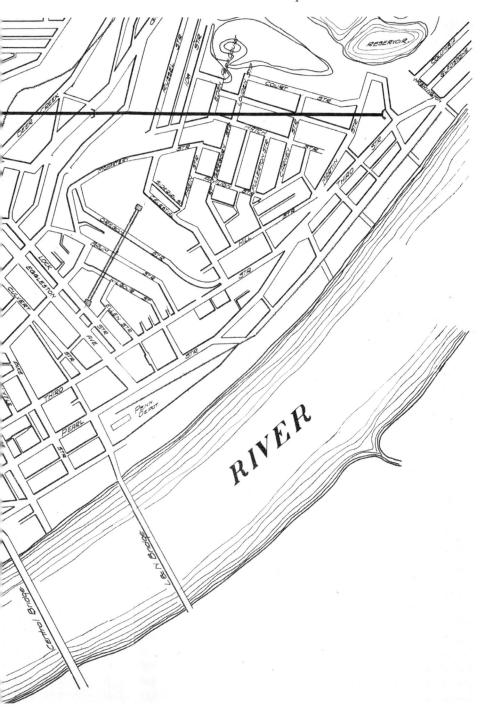

stalking horse for an underground union station. Note the four-track subway in the canal north of the elbow. *Courtesy of the Arnold Report.*

MILEAGE AND EARNINGS OF INTERURBAN ELECTRIC RAILROADS

OPERATING OUT OF VARIOUS CITIES.

For Year Ending June 30, 1911.

1910 CENSUS.

Cities	Population		Miles of Road	Earnings from Operation	
	In City	Average per Sq. Mile in Territory		Total	Per Mile of Road
Cincinnati, Ohio	363,591	*96	342.85	$1,586,357.50	$4,626.97
Toledo, Ohio	168,497	74	614.27	3,131,037.19	5,097.33
Fort Wayne, Ind.	63,933	64	337.61	1,765,311.24	5,228.85
Columbus, Ohio	181,511	69	362.30	2,018,169.62	5,570.44
Indianapolis, Ind.	233,650	67	1,052.21	6,028,849.64	5,729.70
Cleveland, Ohio	560,663	112	678.20	5,296,473.78	7,800.96
Total			3,387.44	$19,826,198.97	
Average					$5,852.86

*For Ohio and Indiana only, since no interurban lines operate into Kentucky.

Interurban traffic chart. *Courtesy of the Arnold Report.*

and Hyde Park as an alternative to the beltway's Duck Creek routing. This was the last proposed tunnel between these two neighborhoods until the concept reappeared as part of OKI's 1971 Regional Rapid Transit Plan.

BUSINESS AND POLITICAL ARGUMENTS

The Arnold Report was organized in such a way as to give the appearance of neutrality while quelling all opposition to construction of a large, publicly financed work for the direct benefit of a dozen private companies.

The Arnold Report

It also created a false sense of urgency by closing with statistics that placed Cincinnati's interurban business well behind that of Cleveland, Indianapolis, Toledo and even much-smaller Fort Wayne, Indiana. According to the report, these lines were not only making more money than any in Cincinnati, they were making more money per track mile, and superior terminal facilities were the reason why. But much of this inequity can be attributed to Cincinnati's hilly surroundings, and that established rail routes had fifty years earlier claimed level sites that were also attractive to industry. Moreover, the poor performance of Cincinnati-area interurbans was probably a boon for area steam railroads, which meant increased business generated by improved interurban terminal facilities were, at least in the short term, a zero-sum prospect.

That this first report was privately funded is a clear signal that the force behind the Rapid Transit Loop was the business community. In the mid-1920s, the Charter Reformers pinned the project's origins on the Republican Machine, despite Democrat reformer Henry Hunt having served as mayor at the time Arnold Report was commissioned. In recent decades, the "corrupt politicians" subway narrative has continued, most often voiced by corrupt politicians.

Chapter 5

THE EDWARDS–BALDWIN REPORT

The Union Depot & Terminal Company attempted to fulfill the conditions of its franchise by staging a groundbreaking in December 1912. The event appears to have been limited to a brief shovel ceremony and the moving of a house near the intersection of Kilgour and Pearl Streets. The shifting of this house to an adjacent vacant lot was not successfully defended in court, and the company's franchise was forfeited on January 1, 1913.

The effort to kill the riverfront union station was helped immeasurably by the March 1913 flood, which threw railroad finances into disarray. With the Union Depot & Terminal Company forced to negotiate a new franchise with the city and its tentative financiers attending to flood damage, planning for Arnold's beltline progressed rapidly. House Bill no. 562, passed April 18, 1913, revised the canal lease, which extended it to include the canal through the neighboring city of St. Bernard and required subway construction to Dixmyth Avenue. How and why Dixmyth Avenue—now Martin Luther King Drive—was determined to be the northern extent of required subway construction is unclear. The Arnold Report saw no functional need for a subway north of Queen City Avenue, and it even calculated the reduced expense of a subway only as far north as Liberty Street. It's possible that this condition was motivated by those who sought to prevent Brighton and Camp Washington from potentially evolving into a freight yard.

THE 1914 REPORT

Construction of Arnold's beltline for the exclusive use of interurbans could not be economically justified. Implementation of a rapid transit service on the beltway, however, promised enormous ridership. In December 1914, a new city-funded report, "Report On Plans and an Estimate of the Cost of a Rapid Transit Railway and an Interurban Railway Terminal for the City of Cincinnati, Ohio," but better known as the Edwards-Baldwin Report, refined and improved upon the recommendations of the Arnold Report by detailing the route, stations and electrical system of what was now termed the Rapid Transit Loop.

The Edwards–Baldwin Report discarded a number of Arnold's extravagances. It reduced the canal subway from four tracks to two and eliminated a third track at stations that would have permitted express service. It ignored the Cincinnati and Westwood Railroad and made no mention of the viaduct that would have connected it with the canal subway. A spur from the belt line to form connections with Clermont County interurbans near the present site of Lunken Airport was also snipped. There was no follow-up to Arnold's Plan no. 5 and its mile-long tunnel to Hyde Park.

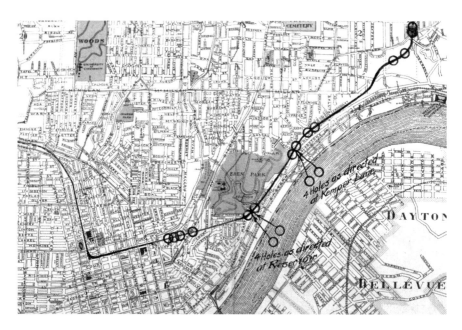

This map of test borings made in 1915 indicates that the Mount Adams tunnel was still under consideration. *Courtesy of the University of Cincinnati Archives & Rare Books.*

The Edwards–Baldwin Report

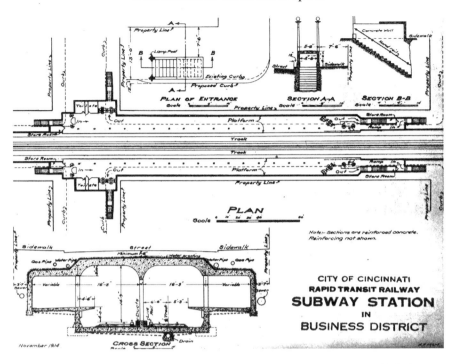

Conceptual subway station design for Walnut Street. *Courtesy of the Edwards–Baldwin Report.*

A pamphlet clipping comparison with other cities. *Courtesy of the Interurban Rapid Transit Bond Issue Campaign Committee.*

E. Comparison of cost with other cities.
1. Boston, Washington Street Tunnel—$3,000,000 per mile per track, $6,000,000 per mile of subway.
2. New York City, Broadway Subway—$1,190,000 per mile per track, $4,760,000 per mile of subway.
3. Brooklyn, Fourth Avenue Subway—$402,000 per mile per track (steam shovel work, as in Cincinnati).
4. Cleveland, proposed Euclid Avenue Subway estimated at approximately $550,000 per mile per track.
5. Detroit, proposed subway $1,320,000, and $1,600,000 per mile per track, (two different subways).
6. Philadelphia, present line, $1,000,000 per mile per track.
7. Cincinnati—
 (a) Subway in downtown district approximately $500,000 per mile of track.
 (b) In Canal bed $320,000 per mile per track.
 (c) System from Oakley to Crawford via downtown loop average cost, $246,000 per mile per track.
 (d) Crawford to Oakley, surface line, $42,000 per mile per track.

Cincinnati's Incomplete Subway

Its two sections and two authors also neatly divided the eventual capital obligations of the loop's lessor and lessee. The first half of the report, written by assistant city engineer F.B. Edwards, summarized speculative routes and stations, with the capital costs to be incurred by the city. Ward Baldwin, a member of Boston's Rapid Transit Commission, wrote the report's second half, which discussed the character and cost of rolling stock and electrical systems, with the capital costs becoming the responsibility of the Cincinnati Street Railway.

General Description

V. ECONOMIES OF BUILDING SUCH A SYSTEM AT PRESENT TIME.

A. Use of Canal bed, already leased from the State.
 1. Provides an entrance on the west side of the City through a thickly settled district.
 2. Provides a connection to the interurbans from Hamilton, Dayton and other northern points.
 3. Provides a connection for lines from the west at the end of the proposed Queen City Avenue Viaduct.
 4. Provides a saving in the amount of excavation for subway construction over that in a city street.
 5. Saves the cost of tearing up and relaying street paving.
 6. Obviates the necessity of planking over the subway trench in order to maintain traffic during construction.
 7. Very few underground structures, such as water pipes, sewers, gas mains, and electric conduits will be encountered.
 8. Allows open construction by terms of an act of Legislature.

B. On East an inexpensive outlet for such a railway and connections for Interurbans from Columbus and northeast, also from towns up the Ohio River, are provided.
 1. By ravines along Duck Creek and Torrence Roads, because
 (a) No improvements have been made.
 (b) Open construction can be used.
 2. By the Ohio River bluff, because
 (a) Property is very cheap.

C. Across north side in open undeveloped country, which should open up rapidly with proper transit facilities, and such can be obtained cheaply, for
 1. Inexpensive open construction can be utilized.
 2. Right of way can be obtained at small expense.

D. Freight Terminal.
 1. Old City Hospital and property to the north provides for tract, which is
 (a) Ample in size.
 (b) Inexpensive (part owned by the City and remainder of low value).
 (c) Centrally located.
 (d) Available.

14

The railway described by Edwards formed the basis for what was actually built. He prescribed a minimum track radius of 1,000 feet outside the downtown area, and all curves would be superelevated up to 6 inches, allowing speeds of forty-five miles per hour to be maintained. Grades would be limited to 2 percent, except for several steeper climbs of less than 500 feet. Stations would be built with 240-foot platforms, expandable to 400 feet. Platforms were to be built 4 feet above track level, and surface and elevated stations were to have a roof "of wood supported on steel framework," similar to the canopies of many elevated stations in New York City. All stations were to have "toilet rooms for men and women."

Edwards's figures were all based on the seventy-foot cars of the Cambridge–Dorchester subway

A pamphlet clipping. Courtesy of the Interurban Rapid Transit Bond Issue Campaign Committee.

56

The Edwards–Baldwin Report

The design of the Rapid Transit Loop as outlined in the Edwards–Baldwin Report was based on the specifications of Boston's Cambridge–Dorchester Subway, which began operation in 1912. *Courtesy of the author.*

(today's Red Line) in Boston, which began operations in 1912. These cars could achieve speeds of forty-five miles per hour on a 2 percent upgrade and fifty-five miles per hour or more on level track. Whereas these cars operated in four-car trains in Boston, Cincinnati's platforms would be built long enough for trains of three cars. Most often they would operate as two-car trains.

A maintenance and storage yard was planned for farmland north of St. Bernard, approximately where the interchange of I-75 and the Norwood Lateral is presently located. This location allowed an interchange with the steam railroads that would tow the rapid transit cars from their place of production to Cincinnati. Edwards called for sufficient storage space for 160 rapid transit cars, an inspection shed, a repair shop, a paint shop and "trainmen's and yardmen's lobbies." The cost estimates of the Edwards–Baldwin Report assumed an initial purchase of between seventy-two and eighty individual cars, about half of the system's maximum capacity.

Scheme One Belt Line and Stations

Whereas the Arnold Report focused on interurban railroads and mentioned city-operated rapid transit service as a future possibility, the Edwards–Baldwin Report focused on the specific character and potential of a city-operated rapid transit service operating on tracks mixed with interurban traffic. It gave detailed descriptions of each of the beltway stations—a matter Arnold's otherwise intensely detailed report did not address.

Many changes to the belt line outlined by Edwards in 1914 were made when final blueprints were made in 1919. Subway and surface routing in the canal right of way did not change, but two stations shifted position and a Mitchell Avenue station was eliminated. In 1914, a surface station planned opposite Crawford Avenue in Northside was shifted to Clifton Avenue, and a subway station at Hopple Street was replaced by a surface station at Marshall Avenue. This second change appears to have been caused as much by cutbacks as by the complicated legal and financial relationship of the Rapid Transit Loop and Central Parkway. It was not known in 1919 if Central Parkway would be built north of Brighton, meaning construction of a subway station at Hopple Street might be an unneeded expense.

In Bond Hill, the Rapid Transit Loop was built in the mid-1920s nearly a half mile north of the alignment planned in 1914. As such, a planned station at Paddock Road was shifted to Reading Road (but never built). Station locations at Montgomery Road and Forest Avenue were retained in their original locations, but the loop itself was rerouted to terminate at Madison Avenue in Oakley.

Three stations on the never-built eastern half of the Rapid Transit Loop were described in the Edwards–Baldwin Report as follows:

> Oakley Station, *5.21 miles going east from Canal Station, is in a subway on private land on the east side of Duck Creek opposite Smith Road. Entrances and exits are at Dacey Avenue.*
>
> Dana Station, *4.5 miles going east from Canal Station, is in the open on private land to the east of Duck Creek and between the N. & W. R. R. and Vista Avenue. The City has considered the building of a viaduct over Duck Creek Valley on the line of Delta Avenue. Should this viaduct be built this station could, without making alteration, be connected with it.*
>
> Madison Station, *3.39 miles going east from Canal Station, is on private land to the south of Madison Road. It is partly covered and partly in the open, with entrances and exits at Madison Road.*

The Edwards–Baldwin Report

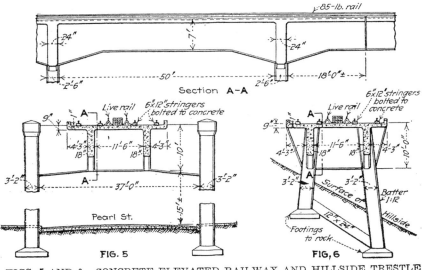

FIGS. 5 AND 6. CONCRETE ELEVATED RAILWAY AND HILLSIDE TRESTLE

Conceptual plans for the concrete trestle stretching between Mount Adams and Torrence Avenue. *Courtesy of the* Engineering News-Record.

Concrete Trestle

A unique engineering challenge was the section of line built above Columbia Avenue on the unstable hillside between the Eden Park Reservoir and O'Bryonville. Edwards envisioned a 6,100-foot concrete trestle running above Columbia Avenue that would solve the engineering problem and provide a spectacular view of the Ohio River and the Kentucky cities of Dayton and Bellevue.

Edwards described the concrete trestle as follows:

> *The plan is to construct concrete piers about 30 feet apart with their foundations sunk and keyed into the undisturbed material. These piers are to be connected by reinforced concrete beams on which is laid a reinforced concrete floor and the track will be laid in ballast on this concrete floor. The grade of the track is such that the ground is not disturbed between the piers. The width of the trenches in which the piers are built is about one-tenth of the span between piers. The concrete piers will act as an anchor holding back and tending to prevent a downward movement of the earth.*

Schemes Two, Three and Four

Unlike the Arnold Report, which considered many different belt line configurations, the Baldwin–Edwards Report assumed a fixed beltway route and concentrated on alternatives for a downtown routing.

Scheme Two imagined a downtown loop that closely mirrored Arnold's. The loop would have three stations: Plum Street between Seventh and Eighth Streets, one beneath the old Fountain Square esplanade between Vine and Walnut Streets and one in Main Street between Seventh and Eighth Streets.

Scheme Three—"Ninth Street Belt Line"—eliminated any use of the canal between Plum Street and Broadway. It kept the same station locations but reached the Mount Adams Tunnel by a circuitous zigzag through the central business district. The station beneath the Fountain Square Esplanade was to remain the same; the Plum Street station was to become the interurban terminal; and the station beneath Main Street was turned east–west beneath Ninth Street.

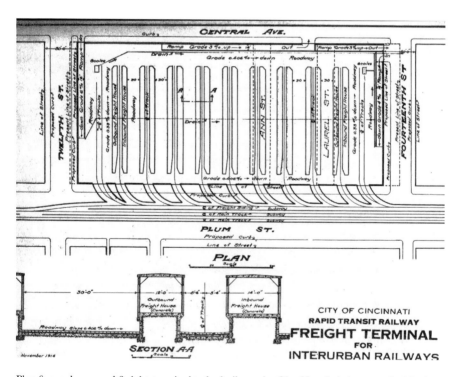

Plan for underground freight terminal to be built on the City Hospital site opposite Music Hall. *Courtesy of the Edwards-Baldwin Report.*

Scheme Four—"Pearl Street Belt Line"—eliminated the Mount Adams tunnel and reached the eastern half of the loop curving along its base via a steel viaduct above Pearl Street. This scheme greatly reduced the amount of tunnel construction by connecting the canal and the Pearl Street Viaduct beneath Walnut Street.

This 2,700-foot tunnel would include stations between Eighth and Ninth Streets and between Fourth and Fifth Streets. The viaduct would rise immediately from the south end of this station, curve east and have a station above Pearl Street at Butler Street. This land is now occupied by Fort Washington Way and the Third Street Viaduct.

That Scheme Four was recommended by the Rapid Transit Commission is hugely significant, as its Walnut Street portal and Pearl Street viaduct would occupy the area to be claimed by the Union Depot & Terminal Company just a few years earlier. This choice indicates that at this early date the city and business community were in agreement that Cincinnati's union station should be built in the West End.

INTERURBANS

Operation of interurban cars on the Rapid Transit Loop would in most or all cases require modification or replacement of equipment, and, in several cases, an adjustment of interurban track gauge. Edwards argued against the installation of a dual-gauge third running rail on the Rapid Transit Loop for use by the broad-gauge interurban railroads, even if they paid for it, because "it is expensive to construct, expensive to maintain and will add to the danger of the derailment of cars with the attendant possibility of accidents to passengers." Further, his calculations determined that the cost of them changing their own gauges was $38,000 less than the cost for the city to install dual-gauge trackage throughout the loop.

More complicated was the matter of how the interurban cars, which drew their power from overhead trolley wires, could operate in traffic mixed with the electrified third rail of the rapid transit trains. Edwards made no mention of the problem, but preliminary cross-section drawings from 1915 to 1917 show trolley poles and an electric third rail for shared operation. The third rail itself presented a problem for the Indianapolis & Cincinnati Traction Company, as its signaling system was tripped by arms that would conflict with it. Compatibility issues, along with construction of connections and junctions with the loop, were to be the financial responsibility of the interurban railroads.

CINCINNATI'S INCOMPLETE SUBWAY

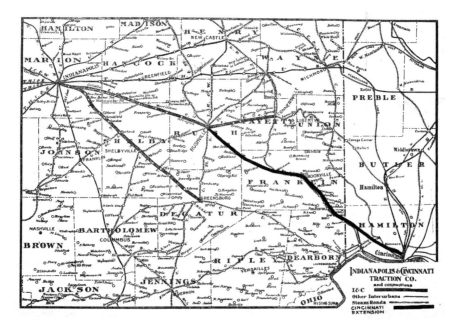

The Indianapolis & Cincinnati, an interurban built only as far as Rushville, planned to use the Cincinnati & Westwood tracks to enter Cincinnati and join the Rapid Transit Loop near Brighton. *Courtesy of the University of Cincinnati Archives & Rare Books.*

BALDWIN'S REPORT ON ELECTRICAL SYSTEMS

The second half of the Edwards–Baldwin Report concerns electrical specifications and estimates of cost and was written entirely by Ward Baldwin based on the schemes devised by Edwards. Since production and distribution of electricity had not yet matured, some railroads at that time built and operated their own power plants. Baldwin called for a coal power plant to be constructed, at an estimated cost of $912,000, adjacent to the Cincinnati Waterworks on Eastern Avenue (now Riverside Drive). The riverfront location allowed delivery of coal by barge or railroad and was just two thousand feet from the Rapid Transit Loop's hillside routing above Torrence Avenue.

The size of this power plant allowed for the simultaneous operation of 36 trains on the Rapid Transit Loop. This rush-hour scenario assumed two-car trains, "on both tracks with a headway of two and one-sixth minutes, at a schedule speed of twenty-four miles per hour, and with one-third minute stops at stations." Five electrical substations, at a total cost

of $225,000, would be spaced evenly throughout the loop. According to Baldwin's rush hour scenario, on average 4.5 trains would be in operation between substations.

Projected Ridership

A traffic survey conducted by the city engineer in 1916 generated detailed ridership projections. Overall average daily ridership was estimated to be sixty-eight thousand, with a slight majority of riders originating on the eastern half of the loop. Fountain Square was expected by a wide margin to be the busiest station, with between twenty-five thousand and thirty thousand passengers daily.

Interurban passengers were expected to constitute 18 percent of the loop's total ridership. As the interurbans ceased operations in the 1920s, their bankruptcies were used as an argument against activating the loop. However, the CL&E interurban survived until the late 1930s, and the Cincinnati Street Railway purchased several defunct interurbans and maintained operations as late as 1942. The real danger to the Rapid Transit Loop's operational finances was not the loss of interurban traffic, but rather a general decline in public transportation ridership.

CHAPTER 6

RAPID TRANSIT LOOP BOND ISSUE CAMPAIGN AND ORDINANCE 96-1917

Following the completion of the Edwards–Baldwin Report in late 1914, the city lobbied the Ohio state legislature in 1915 to further refine the canal lease and pass an enabling act that would create a legal mechanism by which construction of a city-owned rapid transit railroad could begin. The "Bauer Act" (106 Ohio Laws 286) authorized all Ohio municipalities to create five-member Rapid Transit Commissions and conferred upon them the power to levy bonds and administer the construction of rapid transit railroads almost entirely independent of its city government. The act also allowed rapid transit commissions to oversee projects outside the borders of its municipality (the Rapid Transit Loop was planned to travel through the neighboring cities of St. Bernard and Norwood) and to construct parkways "above subway tunnels or alongside surface-running sections of rapid transit railroads." This language, obviously written to Cincinnati's specific situation, could have theoretically been applied anywhere in Ohio.

The act dictated a process of two special elections to precede construction of a rapid transit railroad. The first special election would authorize the sale of municipal bonds; the second approve or disapprove the lease of a city-owned railroad to a private company or companies. Revenues from the lessee would retire bonds and pay for maintenance of the railroad. After retirement of bonds, lease revenues above those necessary for maintenance could be used to fund further capital expenditures or be deposited into the city treasury.

The Bauer Act did not permit Cincinnati to levee a special property tax or create another type of revenue stream dedicated to the retirement of Rapid

WHY THE RAPID TRANSIT PLAN SHOULD CARRY.

Seldom have the people of any municipality an opportunity to do as great good for themselves as that which will be offered to them on April 25 to vote in favor of the Rapid Transit-Interurban bond issue.

FIRST—The Rapid Transit Railway will pay for itself; it will not cost the people of Cincinnati a single cent.

SECOND—This line will cause an annual visitation to Cincinnati of millions of people who can not come here now because of inadequate facilities.

THIRD—It will enable local merchants to supply a trading area of thousands of square miles without delay. Our merchants are now shut out from that territory by lack of transit service.

FOURTH—The Rapid Transit line will enhance the value of every piece of real estate and every building in Cincinnati.

FIFTH—It will give ample facilities for working people and others of moderate means to live in the suburbs and adjacent territory. There they may own their own homes, or at least live amid surroundings healthful, comfortable and cheerful.

SIXTH—The Rapid Transit line will place Cincinnati at a commercial advantage which is now being reaped by Columbus, Dayton, Indianapolis and other cities at our city's expense.

SEVENTH—Besides raising our tax duplicate and thus lowering our rate of taxation, the volume of general business will so largely increase that the opportunities for work will be multiplied many times.

EIGHTH—Completion of this Rapid Transit loop will be the opening wedge for other needed improvements, such as better freight terminal facilities, one or two new railroad stations, as circumstances may require; that is, the railroads using perhaps two stations instead of one.

NINTH—The Rapid Transit line will enable a veritable multitude of visitors annually to become acquainted with the exquisite topography of Cincinnati. Our scenic framing, unique in itself, one of our most attractive features, is practically out of reach of every visitor because we can not invite visitors for lack of facilities.

TENTH—Cincinnati is due for a boom. We have everything and more than any other city in the United States, but our richness, our energy, our vitality is encased in the shell of the surrounding hills. It needs but the opportunity for people to come to us and go quickly when desired to usher in an era of unparalleled prosperity and expansion.

ELEVENTH—The Rapid Transit bond election is the most important municipal election in this city since the election that made possible the building of the Southern Railway and the development of its untold advantages and wealth for the future prosperity of our people and their city.

TWELFTH—Construction of the Rapid Transit line will eliminate the canal within the city limits and permit the building of boulevard for public use thereon by the Board of Park Commissioners.

There are other reasons why the electors of Cincinnati should cast a practically unanimous vote in favor of Rapid Transit.

The *Cincinnati Commercial-Tribune* loop endorsement. Courtesy of the Cincinnati Commercial-Tribune.

Rapid Transit Loop Bond Issue Campaign and Ordinance 96-1917

Vote for the Interurban Rapid Transit Bond Issue and Make Cincinnati Prosper

BETTER HOMES LOWER RENTS
QUICKER TIME TO AND FROM YOUR WORK

Cincinnati Should Be the Largest City in the State of Ohio.

Vote for the Interurban Rapid-Transit Bond Issue and Help Cincinnati Grow

Polls Open Until 5:30 This Afternoon

CINCINNATI'S GREATEST STORE. FOUNDED 1877.

Campaign advertisement by Mabley & Carew. *Courtesy of the* Cincinnati Commercial-Tribune.

Right: Subway ballot. *Courtesy of the Interurban Rapid Transit Bond Issue Campaign Committee.*

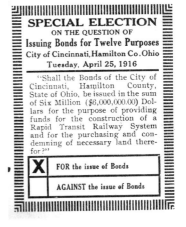

Campaign advertisement by Oldsmobile. *Courtesy of the* Cincinnati Commercial-Tribune.

Transit Loop bonds. The loop's construction debt was instead to be retired by existing revenues, and through the act, it was limited to 2 percent of Cincinnati's assessed property value. In 1915, this meant $6 million, much less than the sum necessary to construct any of the four schemes outlined in the Edwards–Baldwin Report. The first task of the newly formed Rapid Transit Commission therefore was to determine if a useful railroad could be constructed for that sum.

Using Scheme Four of the Edwards–Baldwin Report as a starting point, a plan was devised that eliminated the loop's rapid transit route through Bond Hill and Norwood and instead connected St. Bernard and Oakley with a new crosstown streetcar line on existing city streets. This plan—known as Modification H—budgeted the purchase of necessary private right of way through Norwood for the eventual completion of the loop. Because the area was still mostly rural, this three-mile strip could be purchased inexpensively and held until needed. Modification H reduced the cost of Scheme Four to $5,718,000, just below the $6,000,000 figure allowed by the state.

The Rapid Transit Loop bond campaign was met by no organized opposition. Even the showing of a promotional film on Fountain Square during the week preceding the election—an obvious violation of today's election laws—raised no objections. The $6 million bond issue was approved April 25, 1916, with 39,726 votes for and 6,652 against.

Ordinance 96-1917

After approval of the bond issue, the Rapid Transit Commission entered into lease negotiations with the Cincinnati Street Railway. During this era, cities entered into complicated contracts with street railway companies that guaranteed revenue while maintaining some measure of public control over their operations. Like today's lease agreements between professional sports teams and the municipalities or counties that own their arenas, some cities negotiated more advantageous contracts with their streetcar companies than others. While the Rapid Transit Loop could legally have been operated by the city, a prime motivation for its construction was the opportunity to force a renegotiation of the Cincinnati Street Railway's fifty-year franchise agreement, which would not expire until 1946.

Aside from a general improvement of the franchise agreement, under terms of the Rapid Transit Loop lease, the Cincinnati Street Railway would cover significant capital expenses pertaining to the actual

> **Vote Yes on the Rapid Transit Loop Lease, Tomorrow. Go to the polls early and vote for Cincinnati's Future.**
>
> **Old Cincinnati said "Can't," New Cincinnati says "I Will."**
>
> This is the final word of the Citizens' Rapid Transit Loop Committee. We believe that the city we love, our home, is at the turning point, and that with the coming of Rapid Transit we will have the beginning of a Greater, More Prosperous, Healthier and Happier Cincinnati.
>
> We believe that a Vote for the Loop is a Vote for the best interests of all of us, and it is with pride that we state that every newspaper in the city is for the Loop, and practically all of the Business organizations as well as the Trades Unions.
>
> We as Members of the Committee have had no ax to grind, other than Civic Interest. Old Cincinnati said "Wait." New Cincinnati Commands "NOW." We are proud to be enrolled as citizens of New Cincinnati.
>
> This advertisement was paid for by the subscriptions of members of the Citizens' Rapid Transit Loop Committee and, to a man, they will
>
> **Vote YES for the LOOP and RAPID TRANSIT TOMORROW**

Lease campaign ad, "I Will". *Courtesy of the* Cincinnati Commercial-Tribune.

operation of the railroad. So while the city was limited by the Bauer Act to raising $6 million, the Cincinnati Street Railway agreed to purchase subway cars, lay the electric third rail, install electrical substations and all wiring and even build and operate its own coal power plant. These expenses, obviously contingent on how much of the Rapid Transit Loop was actually built with its allotted $6 million, were expected to amount to as much as $2 million.

Unlike the Cincinnati Southern Railroad's lease, which necessarily could not be negotiated until the entire railroad was nearing completion, the City of Cincinnati's new franchise agreement with the Cincinnati Street Railway would take effect immediately after the special election, months or perhaps years before any contracts were OK'd for construction. This meant the city could take advantage of the favorable renegotiation of franchise fees instantly and exploit a particular aspect of the lease that greatly reduced the cost of the Rapid Transit Loop.

Rapid Transit Loop Bond Issue Campaign and Ordinance 96-1917

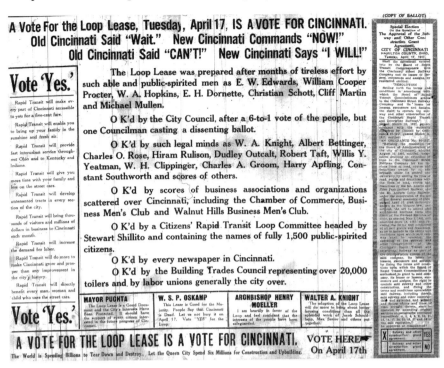

Loop Lease endorsement. *Courtesy of the* Cincinnati Commercial-Tribune.

Upon approval of the lease agreement by the electorate, the Cincinnati Street Railway was obligated to begin payments against the interest and principal of the city's $6,000,000 construction bond issue. Because the Rapid Transit Loop would be built in contracted phases using periodic bond issues, payments from the Cincinnati Street Railway might completely retire the project's earliest bonds before operations began. The brilliance of the lease terms meant that the inability of the $6,000,000 bond issue to build the entire Rapid Transit Loop was only a temporary condition—the bonds would be paid off quickly and action could be taken to complete the loop soon after operations commenced initial sections.

Or at least that's how it was portrayed. In contrast to the Rapid Transit Loop bond campaign, considerable opposition was raised to Ordinance 96-1917. Various "experts" from other cities were invited to speak before business and social clubs, but these individuals more often than not acted to muddy the conversation. Few aside from the city's most astute lawyers understood the true implications of the lease terms, meaning its 2–1 approval

on April 17, 1917, was simply the electorate's second endorsement of the Rapid Transit Loop.

Ohio Supreme Court Declares Ordinance 96-1917 Illegal

The day after the approval of the lease by the electorate, the presidents of two interurban railroads filed suit. Eleven months later, on March 4, 1918, the Ohio Supreme Court declared the loop lease ordinance, approved by a 2-1 margin by the Cincinnati electorate, invalid. The mayor and the president of the Cincinnati Street Railway met the next day and agreed to immediately revert to the terms of the old franchise.

One of the great mysteries of the subway saga is how Ordinance 96-1917 was declared invalid for reasons not raised by the variety of published criticism that survives from spring1917. Generally, the lease ordinance was opposed for these reasons:

(1) Use of the city-owned Rapid Transit Loop by the interurbans would be permitted by a sublease of the loop trackage by the Cincinnati Street Railway, meaning the interurbans would likely be overcharged or kept out entirely, as they were presently.

A VOTE AGAINST THE TRACTION ORDINANCE IS NOT A VOTE AGAINST RAPID TRANSIT

MR. C. C. HARRIS, President and General Manager C., M. & L. Traction Company, says:

"Vote against this loop plan until a contract can be made between the City and The Cincinnati Traction Company that will allow the Interurbans to enter."

GEORGE W. NICHOLS, Director Cincinnati, Georgetown & Portsmouth Traction Company, says:

"If the voters believe the Traction Ordinance provides for the entrance of Interurbans they are being deceived. It is a physical impossibility for the Interurbans to use the loop as provided in the ordinance."

VOTE NO X On this Traction Contract and we will get a better one. Special election next Tuesday, April 17.

Vote No on Lease. *Courtesy of the* Cincinnati Commercial-Tribune.

LOOP LEASE OPPONENTS WILL APPEAL TO COURT; CLAIM IT IS NOT VALID

Having failed to defeat the proposed subway, or "loop," at the polls, W. A. Julian, Chairman of the Campaign Committee that opposed the lease, announced last night that he would immediately bring suit to contest the legality of the ordinance.

Mr. Julian, in a statement sent to The Commercial Tribune, says: "Counsel advises me that this ordinance is in conflict with the constitution of the State of Ohio.

"Therefore, I will immediately bring an action to test the constitutionality of the ordinance.

"This course," writes Mr. Julian, "is to the interest of both the city and the Traction Company. Each is entitled to know at the earliest possible moment whether or not this ordinance is a valid and enforcible contract."

Mr. Julian also states that, in his judgment, the ordinance approved by the people Tuesday is "not only a bad bargain, but an insurmountable obstacle to municipal ownership," and "that the purchase price, fixed by the ordinance, is so greatly in excess of the value of the company's property as to make purchase by the city practically impossible."

Loop Lawsuit article on April 18, 1917. *Courtesy of the* Cincinnati Commercial-Tribune.

(2) Construction of the loop would not significantly increase fare box revenue in a city where virtually all public transportation revenue was monopolized by the Cincinnati Street Railway, raising doubt that the company would ever actually pay debt service on the 1916 bonds.

(3) Although service would be unified with free transfers, ultimate control of the streetcar system would remain the mayor's duty, while operations of the loop would be managed by the Rapid Transit Commission, setting the stage for political turf wars.

The Ohio Supreme Court's ruling made no mention of these nonlegal issues and instead declared the lease invalid because a private corporation—the Cincinnati Street Railway—would be leant credit from a municipality. Why this was a problem in Ohio but not New York, where New York City backed construction of subways operated by the IRT and BRT, was a matter of legal hairsplitting and could have been resolved quickly if not for the chaos created by World War I.

CHAPTER 7

CONSTRUCTION OF SECTIONS ONE THROUGH FOUR

After the electorate's approval of Ordinance 96-1917, the Rapid Transit Commission was, per the conditions of the Bauer Act, legally permitted to issue bonds and commence construction of the Rapid Transit Loop. The canal could have been drained and work begun by late 1917, but the United States entered World War I two weeks before the lease ordinance was approved, and soon after the federal government prohibited the sale of municipal bonds.

Significant preliminary engineering was nevertheless undertaken in 1917 with funds allocated prior to the onset of war, including preparatory work for the Walnut Street subway. But the war did much more than cause a two-year delay—the large-scale sale of gold by warring nations caused a devaluation of those currencies that were backed by it, including the U.S. dollar. As a result, material costs doubled nationwide, and it became clear in 1918, as action in Europe drew to a close, that Cincinnati would be forced to drastically scale back its rapid transit plans.

But the financial situation grew even darker due to ratification of the Eighteenth Amendment on January 16, 1919, just as planning resumed for the Rapid Transit Loop. Prohibition would take effect exactly one year later, closing Cincinnati's many breweries and taverns, putting thousands out of work and throwing municipal finances into chaos. Diminished tax revenues would inhibit the city's ability to borrow money, and although legally permitted and in fact petitioned to do so, the Rapid Transit Commission did not seek an additional bond issue for the Rapid Transit Loop before

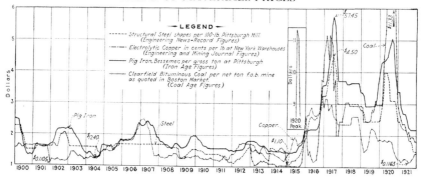

The economic disruption created by World War I, illustrated dramatically in this graphic, scuttled subway plans in several American cities. *Courtesy of the* Engineering News-Record.

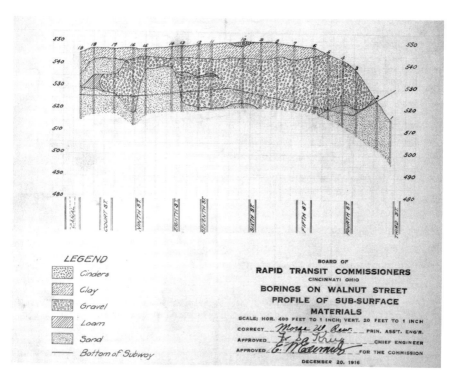

Preliminary design work was performed on the Walnut Street Subway in 1916 and 1917, but no final drawings were made. *Courtesy of the University of Cincinnati Archives & Rare Books.*

construction commenced. With their obligation to build Central Parkway, the commissioners believed it prudent to begin construction of the parkway soon after completion of the canal subway and then return to the Rapid Transit Loop project. The commission also did not attempt to renegotiate lease terms with the Cincinnati Street Railway until it had a clear idea of how much of the railroad could be built for $6 million.

Plans Are Downsized

The public was aware as they went to the polls in 1916 that $6 million was insufficient to build the full sixteen-mile Rapid Transit Loop and that it would be built initially as a two-branch system, its temporary terminal stations connected by a new cross-town streetcar line through Norwood and Bond Hill. But due to the factors mentioned above, it was now impossible to build the compromise known as Modification H. In mid-1919, the Rapid Transit Commission dismissed Modification H, made no plans to build the loop's eastern branch, and resolved to build only the western half of Scheme Four from the Edwards–Baldwin Report.

The new plan that was approved restored the concept of a fully grade-separated rapid transit routing through St. Bernard, Bond Hill and Norwood in place of the Ross Avenue crosstown streetcar of Modification H. It also extended the rapid transit route outside any originally conceived beltway alignment to a terminal station at Madison Road near Cincinnati Milling Machine (later and better known as Cincinnati Milacron), a decision undoubtedly influenced by the appointment of the company's president to the Rapid Transit Commission. This extension east from Norwood would be built on Enyart Avenue, a platted but unimproved street parallel to the Baltimore & Ohio Railroad already owned by the City of Cincinnati.

In its most dramatic cost-cutting move, the Rapid Transit Commission decided not to construct the Walnut Street Tunnel and Fountain Square station. The reason for this decision appears to have been that construction of this section might, in a worst-case scenario, have proven so costly and consumed so much of the $6 million bond issue that the canal subway might not have been finished. With an incomplete canal subway, Central Parkway could not have been built, and the Rapid Transit Commissioners would have failed to complete one of their core tasks.

In a final effort to cut costs, in January 1919, the commission adopted a resolution to acquire properties along the west side of the canal from

Cincinnati's Incomplete Subway

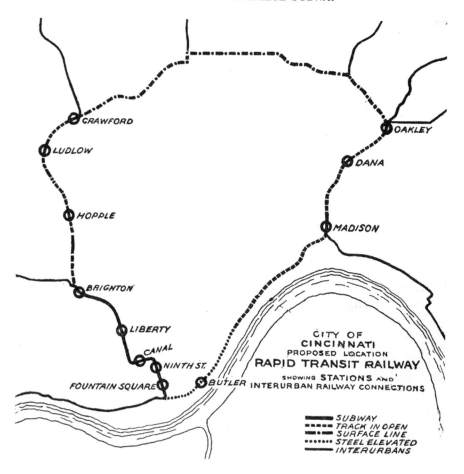

The Modification H plan sold to voters in 1916 included rapid-transit lines to the east and west and a streetcar line across Norwood. *Courtesy of the Interurban Rapid Transit Bond Issue Campaign Committee.*

a point just north of Liberty Street (where the Samuel Adams Brewery is located today) to Mohawk (Linn Street intersection) with the intent to construct this half mile in an open cut adjacent to the future parkway. In order to comply with conditions of the Bauer Act, this construction was required to be entirely outside the bounds of the canal property leased from the state. The matter was studied but abandoned just a month later after it was found that the high cost of property acquisition offered no cost advantage.

With the decision in February to build the canal subway as originally planned, final drawings were ordered and the two-mile tunnel, divided into

Construction of Sections One through Four

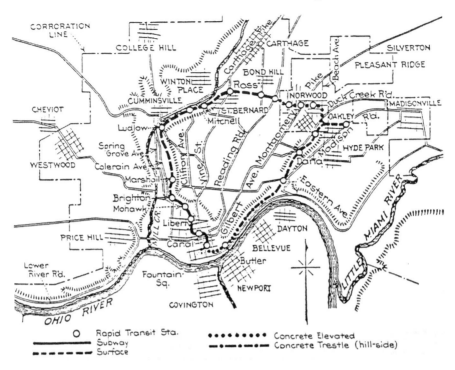

Due to World War I inflation, plans were reworked. Only the west side of the loop was to be built initially, but the Norwood streetcar line was replaced by a continuation of the rapid-transit line east to Madison Road in Oakley. The Walnut Street subway and eastern half of the loop pictured in this map could not be built with the $6 million bond issue. *Courtesy of the Engineering News-Record.*

four contracts, was put out to bid midsummer, and a dam was built at the Plum Street elbow and another at Ludlow Avenue. The stretch between Plum Street and Sycamore Street was drained in September 1919 and contracts one and two were awarded in November.

SECTION ONE

Walnut Street to Charles Street

Section One, site of the Race Street interurban terminal and its associated track work, is the most interesting part of the subway. It was built by D.P. Foley Construction, who earlier built large concrete structures such as the Park Avenue bridge over Kemper Lane and the Mill Creek Interceptor

Present-day aerial view of Section One. *Courtesy of the author.*

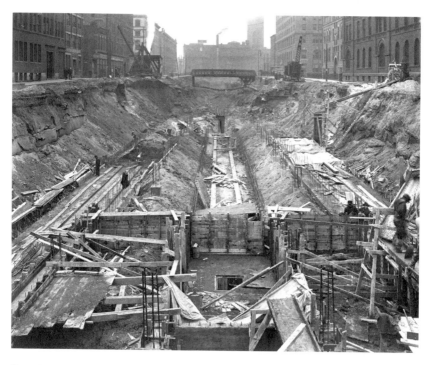

Race Street station platforms under construction in 1920. *Courtesy of the City of Cincinnati.*

Sewer. Ironically, Foley was contracted in the 1950s to demolish sections of the Rapid Transit Loop including the Ludlow Avenue station as preparatory work for the Millcreek Expressway.

The only surviving in-depth discussion of this part of the subway appears in the August 18, 1921 *Engineering News Record*, a publication not kept at any Cincinnati area library. As a result, for the past ninety years, the station's design and various dead-end side tunnels have confused its many legal and illegal visitors.

Its central feature, the interurban terminal, was also to temporarily serve the subway's rapid transit trains. Because the interurban terminal was designed for two-car interurban trains measuring 150 feet in length, rapid-transit trains would also be temporarily limited to a similar length or risk having train doors blocked by the waiting area's pillars. Four turnout stubs, visible at either end of the interurban platform, were intended to serve future platforms for longer rapid-transit trains after traffic increased. The staircase at the center of the terminal platform was intended to permit transfers to these future platforms, similar to pedestrian underpasses in New York City's many four-track subway stations.

Provisions for interurban service included wyes at either end of the station. The east wye was to have been completed as part of the Walnut Street Tunnel, and it exists today as a single-track tunnel extending east from the Walnut Street stubs to a point near Main Street. The west wye extends south under private property between Elm Street and Plum Street.

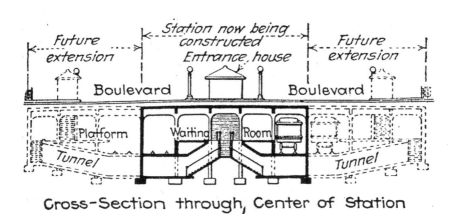

Diagram illustrating the Race Street Station's full five-track plan. *Courtesy of the* Engineering News-Record.

Cincinnati's Incomplete Subway

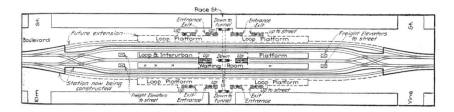

Diagram illustrating the Race Street Station's full five-track plan. *Courtesy of the* Engineering News-Record.

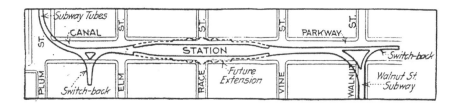

Subway Section One. *Courtesy of the* Engineering News-Record.

It is in pristine condition since the water main that obscures its existence was installed at roughly the same time spray paint was invented.

Work on Section One was delayed by a litany of material shortages including steel, coal, wood and even lime and burlap, and although work technically began in January 1920, progress was piecemeal until June. The Rapid Transit Commission awarded Foley an extension to its fifty-four-week contract in acknowledgement of these material shortages, and in the interest of progress on the project, City engineer Frank Krug approved the substitution of various materials. For example, Section One was built with a lower-quality steel rebar than originally contracted; Krug allowed its use as long as 20 percent more was used. In 1921, there was a lumber shortage, and the type of wood outlined in the bid books for use as rail stringers was not available.

These change orders gave rise to the rumor that the subway was poorly built. This is obviously not the case, as it has required minimal maintenance in the eighty years since it was built. Tellingly, Section One was not a focus of 2010's Rapid Transit Tubes Joint Replacement project.

Construction of Sections One through Four

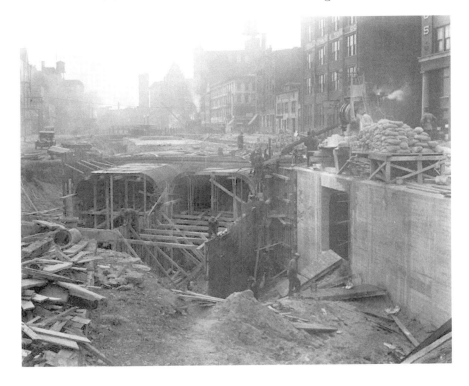

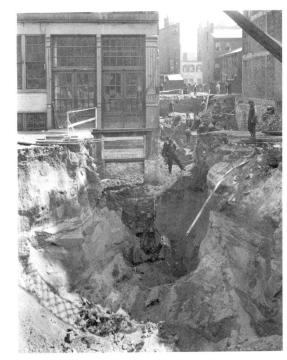

Above: Walnut Street stubs and east wye construction in 1920. *Courtesy of the City of Cincinnati.*

Right: West Wye under construction between Elm Street and Plum Street. *Courtesy of the City of Cincinnati.*

Cincinnati's Incomplete Subway

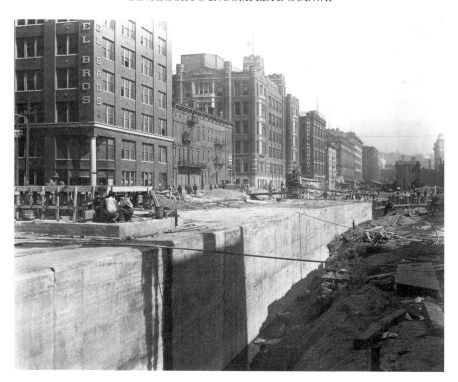

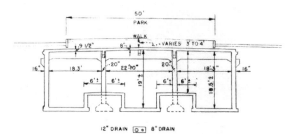

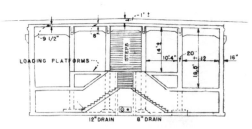

Above: Section One nearing completion in October 1920. *Courtesy of the City of Cincinnati.*

Left: Race Street station cross-section schematics. *Courtesy of the Cincinnati Historical Society.*

Construction of Sections One through Four

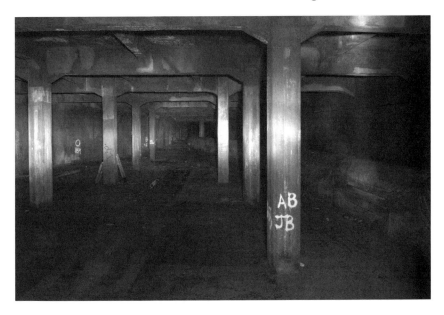

Present-day view of the track switching area and water main west of the Race Street station platforms. *Courtesy of the author.*

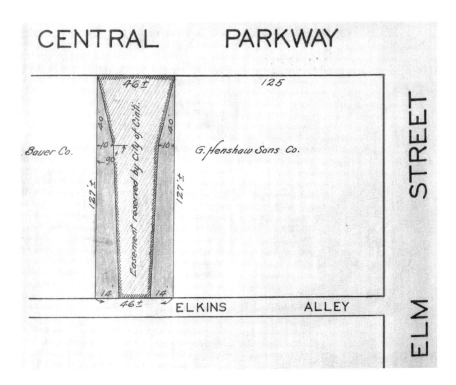

West wye and its easement. *Courtesy of the University of Cincinnati Archives & Rare Books.*

SECTIONS TWO AND THREE

Sections Two and Three were both built by Hickey Brothers of Columbus, Ohio, and compose the simplest and most inexpensively built mile of rapid transit subway in the United States. Combined, these two sections cost $1,050,000 in 1920s dollars, and their construction involved little more

Present-day aerial view of Sections Two and Three. *Courtesy of the author.*

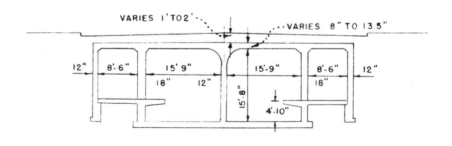

Liberty Street cross-section. *Courtesy of the Cincinnati Historical Society.*

Construction of Sections One through Four

challenge than the construction of a similar tunnel beneath a cornfield. Utilities crossed it at just three or four places north of the elbow, but none ran parallel to the canal. Streetcars crossed Sections Two and Three on just two bridges: one at Twelfth Street and another at Liberty Street.

The monotony of these two sections is broken only by the Liberty Street Station, provisions for another subway station at Mohawk and turnout stubs for the never-built underground freight depot at the former City Hospital property opposite Music Hall. The Liberty Street Station is situated slightly north of Liberty Street, and entrances were built on the northeast and northwest corners of Central Parkway. Today, only the northeast entrance remains, as the east entrance was probably blocked as part of the Liberty Street widening project.

The station's east platform was converted into a demonstration nuclear-fallout shelter in the 1960s. The conversion involved minimal structural

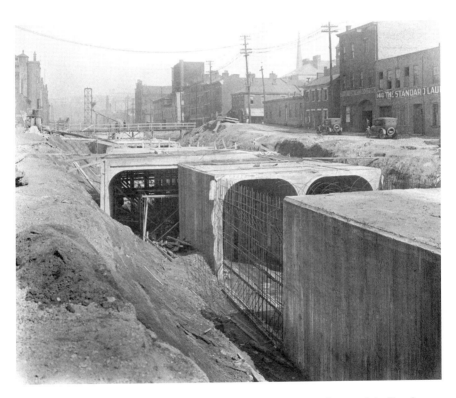

View of Section Two construction near the freight terminal stubs. *Courtesy of the City of Cincinnati.*

CINCINNATI'S INCOMPLETE SUBWAY

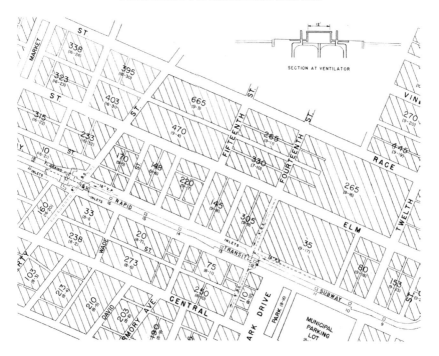

Section Two schematic drawing. *Courtesy of the Cincinnati Historical Society.*

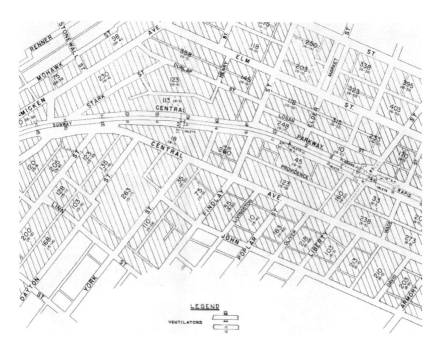

Section Three schematic drawing. *Courtesy of the Cincinnati Historical Society.*

Construction of Sections One through Four

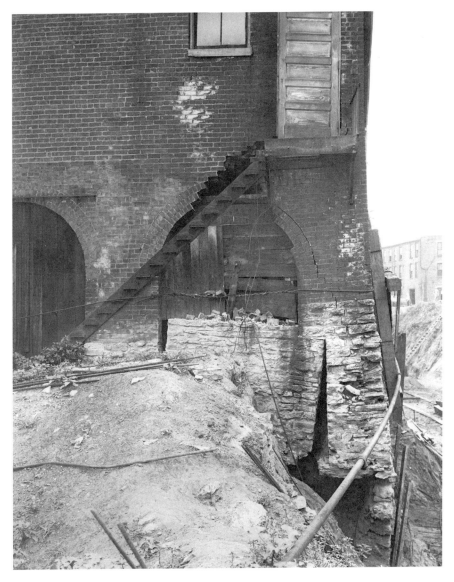

Damaged building near Findlay Street in 1921. *Courtesy of the City of Cincinnati.*

modifications, limited mostly to installation of permanent lighting and plumbing for toilets and decontamination showers. An alarm system was allegedly installed, but it did not prevent the ransacking of the station by vandals in the 1980s. Since that time, dozens of the bomb shelter's water canisters have been taken as souvenirs, and few remain.

At Liberty Street, the subway's ventilation design changed. Sections One and Two were ventilated by regularly spaced box-shaped housings in Central Parkway's landscaped median. These vents were removed in the 1950s. North of the Liberty Street Station, Section Three's ventilation was provided by grates on either side of Central Parkway. This design continued north through Section Four.

SECTION FOUR

With work underway on Sections One, Two and Three, the Rapid Transit Commission planned to issue $1,500,000 in bonds in January 1921 in order to fund construction of Sections Four and Five, with each contract amounting to approximately $500,000, and to purchase $500,000 worth of property between Mohawk and Brighton to be used by Central Parkway. This action was delayed by Mayor Galvin, who asked the commission to delay this large bond issue several months in order to protect the city's bond rating. According to this plan, bonds were sold in July and work commenced immediately thereafter.

In contrast to Sections Two and Three, significant engineering challenges were encountered by F.R. Jones, the contractor hired to build Section Four. Between Mohawk and Brighton, subway excavation corrupted the foundations of several dozen homes. In Brighton, the landmark multistory warehouse now known as the Mockbee Building suffered foundation damage as did the Brighton subway station itself, which was partly rebuilt.

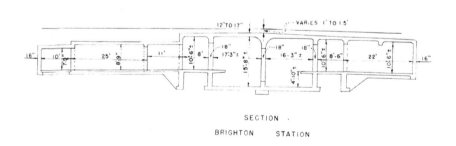

Brighton Station cross-section. *Courtesy of the Cincinnati Historical Society.*

Construction of Sections One through Four

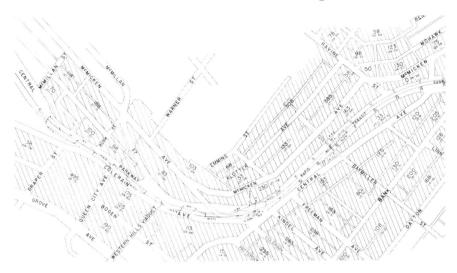

Section Four schematic. *Courtesy of the Cincinnati Historical Society.*

Although the event affected fewer than one hundred residents and litigation did not delay construction or, in the end, cost the Rapid Transit Commission a decisive sum, the damage was used to argue against future subway construction.

After the subway was built, an earthen ramp was built to replace the old stone and iron Brighton Bridge. This ramp remained for about five years until it was replaced by a new all-concrete Brighton Bridge, built as part of the Central Parkway Project. This is the only one of four originally planned bridges to have been built over Central Parkway; however, the Dixmyth Avenue Bridge will finally be built as a Martin Luther King Drive–Hopple Street overpass as part of the upcoming I-75 reconstruction.

Section Four ended about one hundred feet north of the Brighton subway station and temporary ramp and only a few photographs taken during initial construction of Central Parkway show these temporary subway portals. These photographs give no indication as to what type of door or other covering was used to block access to the subway during this time period. In 1926, the subway was extended north from this point, but no excavation was necessary as Central Parkway was built as a bridge structure over Section Five north to Draper Street.

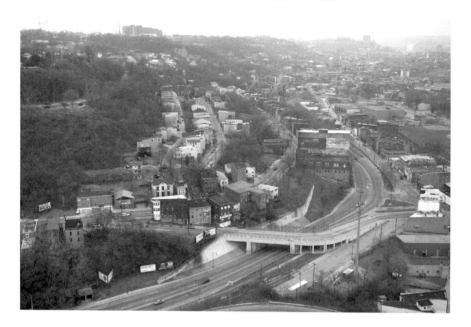

Above: Present-day view of Brighton, looking south. *Courtesy of the author.*

Left: Landslide damage to the Bright Station in November 1922. *Courtesy of the City of Cincinnati.*

Construction of Sections One through Four

West End Rapid Transit

Excluded for topographical reasons from the Rapid Transit Loop plan was the Cincinnati, Lawrenceburg & Aurora, an electric interurban railroad that terminated at Anderson Ferry. Passengers were forced to transfer near the ferry slip to the broad streetcars of the Cincinnati Street Railway, which made slow progress from that point into the city. In 1915, the City of Cincinnati granted a franchise to the West End Rapid Transit Company, which planned to build a mile-long viaduct over the Mill Creek and nearby railroad tracks and deliver the CL&A's interurban cars to a terminal facility on Third Street.

Private financing for this project collapsed during World War I, but the concept was revived in 1919, with hopes that it might be publicly funded. In 1920 the Rapid Transit Commission denied the request of a petition signed by hundreds of Saylor Park residents to place a $1 million bond issue on the ballot, and no improvements were made. The awkward Anderson Ferry transfer continued until 1930, when the defunct CL&A's track was purchased by the Cincinnati Street Railway, converted to broad gauge, and carried streetcars into former interurban territory until 1940.

Freight was a significant part of the CL&A's business, and failure of the viaduct project motivated the tiny railroad, like the other interurbans, to truck its freight between Cincinnati and its terminus. But in an innovation with global implications, it created its own purpose-built steel shipping

The CL&A invented multimodal container shipping in the early 1920s. *Courtesy of the Engineering News-Record.*

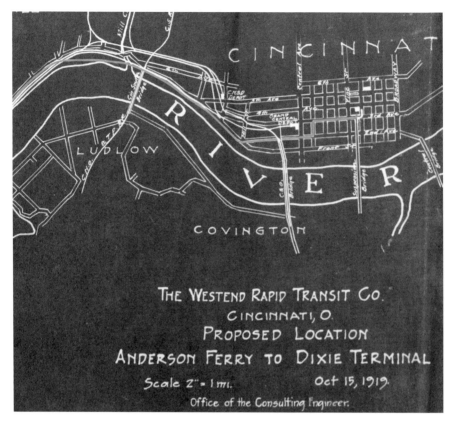

The West End Rapid Transit line would not have been a fully grade separated railroad similar to the Rapid Transit Loop as the interurban cars of the CL&A were planned to travel in Third Street for at least a mile in their approach to Dixie Terminal. *Courtesy of the University of Cincinnati Archives & Rare Books.*

containers that were quickly transferred between its trucks and rail cars by an overhead gantry. This operation only survived for about five years, but word of its effectiveness spread quickly through numerous articles in engineering journals. Although someone somewhere would have eventually invented multimodal container shipping, like so many interesting footnotes in Cincinnati's history, it has been forgotten.

CHAPTER 8

CONSTRUCTION OF SECTIONS FIVE THROUGH NINE

Unlike Rapid Transit Loop contracts one through four, which survive in the form of the Central Parkway subway tunnel, little remains of contracts five through nine. North of the subway's Draper Street portals, eight of nine planned miles were built northeast to Oakley, including three surface stations, seven overpasses, four underpasses and three short tunnels. Like the Central Parkway subway, no track or electrical equipment was installed. Exclusive of real estate and engineering costs, a total of $2,050,000 was spent constructing the two-mile subway, but just $1,575,000 on the eight-mile combined distance of sections five through nine.

SECTIONS FIVE AND SIX

Hopple Street is the northernmost point where Central Parkway was planned to be built directly over the Rapid Transit Loop, and this eventuality appears to have influenced the small size of Section Five relative to Section Six. Ludlow Avenue would have divided the two contracts more equally, but as-built, $150,000 Section Five was the Rapid Transit Loop's smallest contract.

Looking ahead to Section Six and beyond, in 1922, the Rapid Transit Commission investigated use of land parallel to the B&O Railroad by the Rapid Transit Loop as an alternate to the canal. On September 8, members of the commission rode a chartered train to Norwood and back, noting the space adequate for two additional tracks. No freight spurs or passing sidings

CINCINNATI'S INCOMPLETE SUBWAY

Present-day view of the subway's portals. *Courtesy of the author.*

Present-day aerial view of Interstate 75 at site of Marshall Avenue station. *Courtesy of the author.*

Construction of Sections Five through Nine

existed along the south side of the B&O mainline for three miles, and due to topography, it was unlikely that any would ever be built. Aside from cost savings, such a routing would free this section of the line from the constraints of the Bauer Act and ease the eventual construction of Central Parkway between Ludlow Avenue and Mitchell Avenue. But after further study, the cost savings were shown to be minor, as the section built in place of the canal cost just $325,000 or approximately as much as one block of the unbuilt Walnut Street subway.

Nothing whatsoever remains of contract six between the Ludlow Avenue Viaduct and Mitchell Avenue, which originally included the Ludlow Avenue station, an overpass and station at Clifton Avenue and another overpass over Mitchell Avenue.

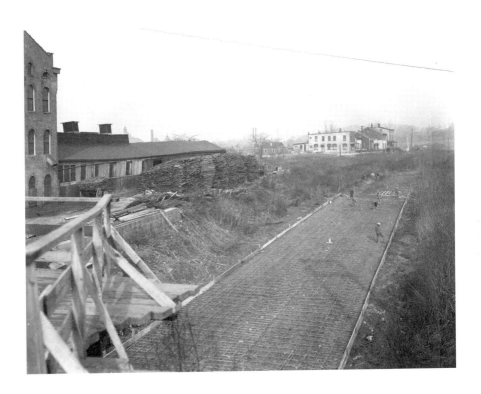

The Hopple Street tunnel was built over previously graded Section Five right of way in 1926–1927. *Courtesy of the City of Cincinnati.*

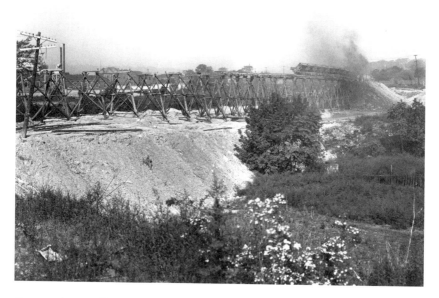

Construction near Bates Avenue in October 1922. *Courtesy of the City of Cincinnati.*

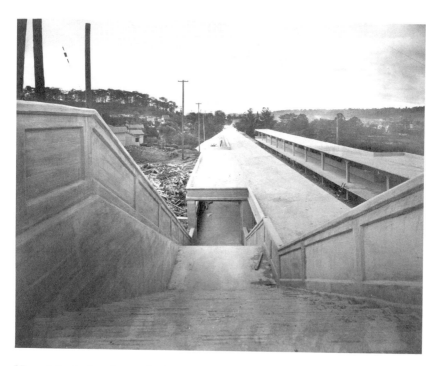

View of the Ludlow Avenue Station from the Ludlow Viaduct. *Courtesy of the City of Cincinnati.*

Construction of Sections Five through Nine

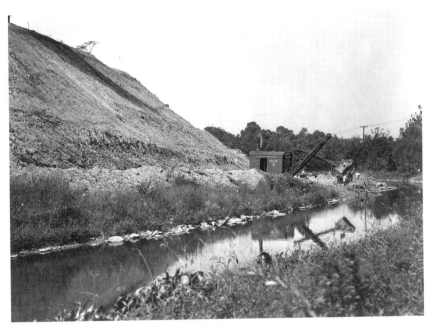

Earthwork near canal, somewhere on Section Six. *Courtesy of the City of Cincinnati.*

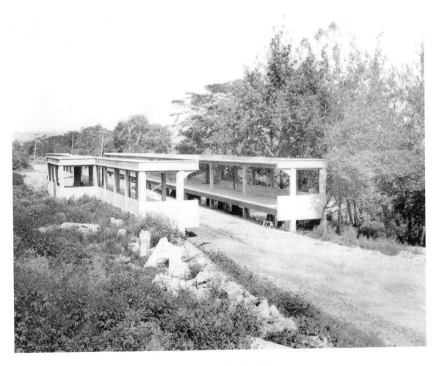

Clifton Avenue Station. *Courtesy of the City of Cincinnati.*

A RESOLUTION

Accepting the grant by The City of St. Bernard, Ohio, of permission to The City of Cincinnati, Ohio and The Board of Rapid Transit Commissioners of The City of Cincinnati, Ohio, to construct, maintain and operate a rapid transit railway system in, across and under certain streets in the City of St. Bernard, Ohio.

Whereas the Council of The City of St. Bernard, Ohio, on June 11, 1925, duly passed an ordinance known as Ordinance No. *12-1925* and,

Whereas the Mayor of The City of St. Bernard, Ohio, on June 11, 1925, approved said ordinance, and

Whereas said ordinance is as follows:

AN ORDINANCE NO. *12-1925*

Granting permission to the City of Cincinnati, Ohio, and the Board of Rapid Transit Commissioners of the City of Cincinnati, Ohio, to construct, maintain and operate a rapid transit railway system in, across and under certain streets in the City of St. Bernard, Ohio.

BE IT ORDAINED by the Council of the City of St. Bernard, Ohio:

Section 1. That permission is granted to the City of Cincinnati, Ohio and the Board of Rapid Transit Commissioners of the City of Cincinnati, Ohio, to construct, maintain and operate a rapid transit railway system in, across and under streets of the City of St. Bernard, Ohio as follows: Across Ross Avenue by means of a subway underneath the surface of Ross Avenue, the right of way for said subway being 36 feet, more or less, wide, the center line of said right of way intersecting the south line of Ross Avenue at a point 17 feet, more or less, west of the intersection of the west line of Tower Avenue and extending northeastwardly across Ross Avenue along a 6° curve to the north line of Ross Avenue; across Carthage Pike by means of a subway underneath the surface of Carthage Pike, the right of way for said subway being 40 feet, more or less, wide, the center line of said right of way intersecting the west line of Carthage Pike at a point 345 feet, more or less, south of the south line of Bank Avenue, and extending eastwardly across Carthage Pike along a 100 foot spiral on a 25° curve to the east line of Carthage Pike.

Section 2. That permission is hereby granted to the City of Cincinnati, Ohio, and The Board of Rapid Transit Commissioners of the City of Cincinnati, Ohio, to move, change, elevate, relocate, and re-construct, at the sole expense of the City of Cincinnati, Ohio, and The Board of Rapid Transit Commissioners of the City of Cincinnati, Ohio, any sewer, sewer connection,

St. Bernard Ordinance. *Courtesy of the University of Cincinnati Archives & Rare Books.*

Construction of Sections Five through Nine

Present-day view of Rapid Transit Loop Section Seven right of way in St. Bernard. *Courtesy of the author.*

SECTIONS EIGHT AND NINE

Uncertain in 1920 as to how much the $6 million bond issue could build, the Rapid Transit Commission waited to begin right of way acquisition and design work for the route through St. Bernard, Bond Hill and Norwood until the canal subway was complete. Whereas only minor pieces of bordering property were necessary to build along the canal, beginning in 1924, the commission acquired easement or title to approximately one hundred pieces of property of all shapes and sizes between the canal and the line's terminus at Madison Road in Oakley.

Between Bond Hill and Oakley, the Baltimore & Ohio Railroad was built in the 1850s on a perfectly straight alignment for a distance of over three miles. As predicted in Arnold's 1912 report, the area was developing quickly in the mid-1920s, and due to new industries built along Ross Avenue, the Rapid Transit Loop's alignment was shifted two thousand feet north to open land north of the B&O mainline.

The Rapid Transit Commission was able to cheaply secure right of way through open lands between the canal and Section Avenue. This

The Rapid Transit Loop reused the B&O's bridge over the canal north of St. Bernard. *Courtesy of the City of Cincinnati.*

Grading near the St. Aloysius Orphanage in August 1924. *Courtesy of the City of Cincinnati.*

Construction of Sections Five through Nine

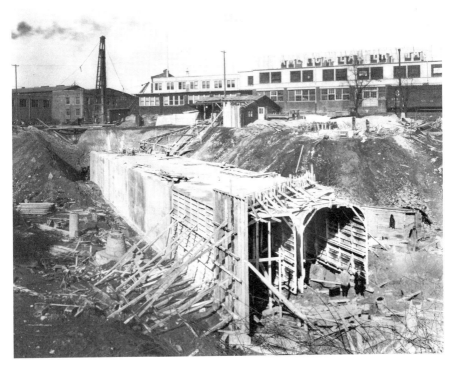

Section Avenue Tunnel preliminary work. *Courtesy of the City of Cincinnati.*

included a route across the seventy-acre farmlands of the St. Aloysius Orphanage, purchased for $20,700, and a total of $28,296 worth of property purchased from the City of Norwood, with the bulk of it in Waterworks Park. A 248-square-foot parcel near the Norwood Incinerator, probably the smallest piece of property involved in the entire project, was purchased for $62.

In 1924, the property on both sides of Harris Avenue east of Montgomery Road was owned by the Boss Washing Machine Company, which, as luck would have it, did not completely fill the odd-shaped piece of land between Harris and the B&O. Easement was granted for $4,529, and in 1926, the Rapid Transit Commission was able to build a tunnel beneath Harris Avenue of just nine hundred feet in length, a significant savings over the 1914 plan, which planned a tunnel in excess of two thousand feet. The Boss Washing Machine property was later overtaken by Zumbiel Packaging, a building that was eventually expanded to incorporate the tunnel's portals into its basement. This tunnel was filled in 2004.

Present-day view of the Harris Avenue Tunnel. This tunnel was filled in 2004. *Courtesy of the author.*

The Rapid Transit Commission was less fortunate a half mile west, where by odd coincidence another washing machine company, the American Laundry Machinery Company, drew up plans in 1924 for a four-story factory and did not grant easement across its property. The line was originally to have crossed diagonally beneath the intersection of Ross and Section Avenues and continued a diagonal path across open land to an underpass beneath Montgomery Road, immediately north of the B&O underpass; instead, the Rapid Transit Commission was forced to build a tunnel of about seven hundred feet in length beneath Section Avenue, a street that did not physically exist ten years earlier.

East of Forest Avenue, a contiguous right of way to Madison Road in Oakley was acquired, but no construction work was performed east of Norwood Waterworks Park. As part of the Edwards–Baldwin plan, the Rapid Transit Loop was to have traveled through the park to the present location of the park's tennis courts and then passed beneath the B&O mainline on an alignment just west of Beech Street. The loop would have traveled due south in an open cut parallel to Beech Street, opposite U.S. Playing Card, to a station between Smith Road and Edmonson Road.

Instead, in order to reach the newly conceived terminus at Madison Road, the Rapid Transit Loop was redirected to parallel the B&O mainline and pass beneath it just west of the stone arch Duck Creek Road underpass,

Construction of Sections Five through Nine

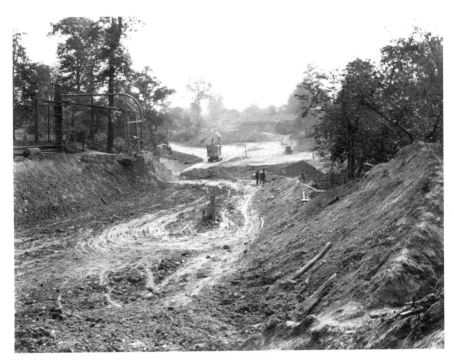

View of construction in Norwood Waterworks Park. This marked the easternmost extent of construction. *Courtesy of the City of Cincinnati.*

Present-day view of Norwood Waterworks Park. The Harris Avenue tunnel is at bottom right. *Courtesy of the author.*

which dates from the B&O's original construction in 1855. A small piece of property was acquired from U.S. Playing Card south of the B&O and west of Duck Creek Road; from that point, the Rapid Transit Loop was to pass over Duck Creek Road and then travel east across undeveloped property that is now Interstate 71.

East of today's I-71, the Rapid Transit Loop reentered Cincinnati and was planned to be built on a three-thousand-foot strip of city-owned property east to Madison Road. Enyart Avenue, which existed only on paper, paralleled the B&O mainline and in concept offered a perfect right of way. Unfortunately, the situation was complicated by a freight siding along the B&O's south track that was used by one or more of the small companies located south of Enyart Avenue. The Rapid Transit Commission was unable or more likely unwilling to secure a straight right of way by power

The right of way acquired near Enyart Avenue in Oakley followed a circuitous route through the neighborhood. *Courtesy of the University of Cincinnati Archives & Rare Books.*

Construction of Sections Five through Nine

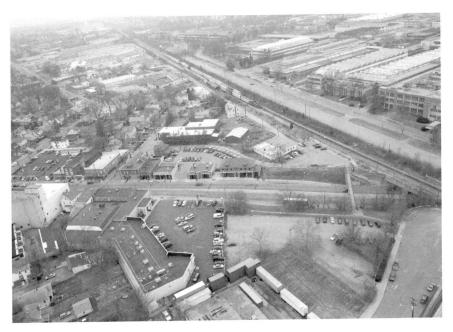

Present-day view of Madison Road near the abandoned Cincinnati Milacron complex. The Rapid Transit Loop's Section Nine was planned to terminate at this point, but no work was undertaken on this section. *Courtesy of the author.*

of eminent domain and was forced to make an odd deviation from Enyart Avenue between Verne Avenue and Appleton Avenue to accommodate the tiny Fitch Dustdown Company.

The Fitch Dustdown Company, manufacturers of "'Dustdown': a powder for dustless sweeping and non-trackable floor brushes," refused to sell the part of its property immediately south of Enyart Avenue, where it accessed the B&O's freight siding. It demanded damages of $21,000 in granting easement to the Rapid Transit Commission through the center of its property; therefore, the entire alignment east of that point had to be moved south of Enyart Avenue in order to maintain access to the north parcel.

Through this hassle and expense, the marooning of Fitch Dustdown was avoided, but north of St. Bernard where the Rapid Transit Loop deflected east from the canal, an inaccessible island was formed between it, the B&O mainline and Norfolk & Western yard. The owner of the property, Maurice E. Lyons, demanded that a bridge or underpass be constructed in order to provide access, but it is unclear as to whether either were actually built. Construction of a crossing might have been delayed until tracks were laid

since the graded Rapid Transit Loop right of way did not present a barrier to people or tractors. This island, measuring 1,500 by 300 feet, was also a prime location for the line's storage yard and shop facilities, but acquisition of any lands for that purpose were not pursued as they would be the responsibility of the line's lessee. When the Millcreek Expressway and Norwood Lateral were constructed in the 1950s over the exact route of the Rapid Transit Loop, no access was provided to this area.

Talks Resume with the Cincinnati Street Railway

Construction of the Section Avenue tunnel and other modifications to Sections Seven, Eight and Nine meant insufficient funds were available to complete Section Nine east of Norwood Waterworks Park. A contiguous right of way was secured between the park and Madison Road, but the $6 million bond issue, as well as proceeds from the sale of small pieces of surplus property, were exhausted by 1927 and no more work could be undertaken. As priority was made of securing this right of way, no stations were built along this stretch.

In 1926, the Rapid Transit Commission reentered negotiations with the Cincinnati Street Railway. Automobile ownership had doubled since 1920 and streetcar ridership's upward trend, unbroken for thirty years, began a steady decline. Meanwhile all of the interurbans with the exception of the College Hill line had gone out of business. It was a radically different economic environment than in 1917, when Cincinnati voters approved Ordinance 96-1917, and figures from the 1916 Traffic Report that the ordinance had been based on were no longer of any use. Before negotiations between the City of Cincinnati and Cincinnati Traction could begin, a new traffic study was needed.

CHAPTER 9
CENTRAL PARKWAY

George Kessler's 1907 report, "A Park System for the City of Cincinnati," announced that Central Parkway would constitute an "improvement similar to Boston's Commonwealth Avenue and be otherwise unparalleled except in European cities." The landscaped median of Boston's most famous street is lined today, as it was during Kessler's time, by hundreds of handsome nineteenth-century homes and apartments. The destiny of Cincinnati's Central Parkway, by contrast, can only be described in polite terms as a profound anticlimax.

The failure of Central Parkway and its subway are two sides of the same coin: the parkway increased the cost of the subway, and the easy automobile commutes it enabled from Spring Grove Avenue and Hamilton Avenue reduced potential subway ridership. Meanwhile, without an active subway, development along the parkway took on an automobile-centric character unimaginable to those of the horse and buggy era in which it was conceived.

The language of the 1915 Bauer Act framed the rapid-transit project as being ancillary to the construction of a boulevard in place of the Miami–Erie Canal; the 1928 "Report of the Rapid Transit Commissioners" reiterated that fact in its synopsis of the Central Parkway project. That the title of the commission, as defined by its enabling act, did not include reference to its primary duty has done a great disservice to the public's understanding of the failure of the subway project.

Although construction of Central Parkway could have been administered by the City Engineering Department or Park Commission, it appears that

View of Central Parkway and the citywide parkway plan devised in 1907 by George Kessler. *Courtesy of George Kessler's 1907* A Park System for Cincinnati, OH.

the Rapid Transit Commission was given both duties in order to ensure that whichever administrative body built the subway could be held accountable if it was built in such a way as to preclude construction of the boulevard. The Bauer Act did not, however, prescribe a specific design or length for the canal boulevard, and the original Central Parkway plan put before voters in 1921 included the Cheapside canal spur.

Turning south at a right angle from the canal proper, this plan contemplated a nine-hundred-foot-long roadway with a thirty-foot landscaped median

Central Parkway

A civic mall was envisioned for Central Parkway in 1925. *Courtesy of the City of Cincinnati.*

passing through land currently occupied by the Hamilton County Justice Center, terminating at East Eight Street on land presently occupied by the Blue Wisp Jazz Club. This extension served no real transportation need but was instead motivated by the parkway project's funding structure.

Because a city street of this type could not be funded by tolls, the bulk of construction bonds were to be repaid from general revenues. Cities such as Kansas City funded boulevard projects with supplementary bond issues repaid in part by a special assessment levied on adjacent properties. The Cheapside route, by bisecting two established city blocks, increased the size and value of the as-yet undefined assessment zone and theoretically could help fund the northern parts of the parkway where there was little of value to assess.

Kessler envisioned Central Parkway traveling on the canal right of way as far north as Bond Hill; the Bauer Act only made legal provisions for it

as far north as the city limits north of Mitchell Avenue. The Rapid Transit Loop's Section Six north to Mitchell Avenue was lawfully built to permit a boulevard to be built next to it, but funds limited its construction to a terminus at Ludlow Avenue.

With subway contracts 1, 2, and 3 nearly complete, and with construction of Section Four underway, the Rapid Transit Commission ordered the city engineer to prepare plans for the parkway in May 1921. In addition to the utilization of the Cheapside canal spur, this first plan included a parking lot in the parkway median for the block immediately north of the courthouse, with a total project cost of $5,346,000.

Estimating a $1,137,000 assessment, a bond issue for $4,208,500 was defeated August 9, 1921, by a 2–1 margin. This sharp rebuke not only put parkway plans on ice, but it illustrated that during the city's fiscal crisis no supplementary rapid transit bond issue had any hope of passage. The Rapid Transit Commission did not attempt another bond issue until fall of 1923. Costs were reduced with the elimination of the Cheapside spur, but the parkway bonds failed for a second time, with a vote of 46,603 for and 59,160 against. The exact same parkway plan and bond issue was put before the voters on April 29, 1924, and passed 20,588 for and 9,008 against.

Construction

Before construction of the actual roadway, a comprehensive surveying effort undertaken in late 1924 and 1925 determined the precise borders of the former state-owned canal property and what small pieces of private property were needed to construct the parkway to a consistent width. In addition, this survey enabled an accurate assessment of bordering properties in order to calculate the precise value of bonds that assessment income could back.

Another purpose of the survey was to design new grades for cross streets—streets that formerly crossed the canal on bridges to rise in their approach and streets that terminated at the canal tended to descend. This was typically quite subtle but nevertheless required the services of over a dozen lawyers. In mild cases, property owners were compensated by adding or reducing a single step to their front entrance. In other cases, exterior doors were raised or lowered. In an ironic instance, a gas station facing the Race Street subway station was awarded over $20,000 to reconstruct its fuel tank.

The survey comprised an enormous amount of work, with much of it preserved in boxes kept at Blegan Library at the University of Cincinnati.

Central Parkway

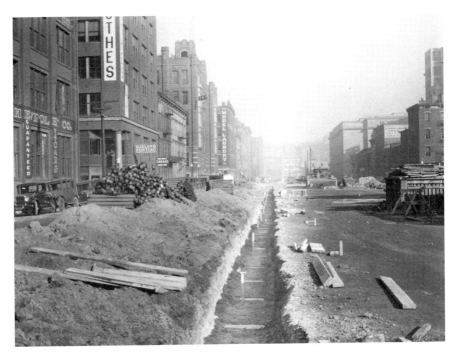

A 1926 view of early work on the parkway's landscaped median. *Courtesy of the City of Cincinnati.*

As Central Parkway was being built, Mayor Murray Seasongood criticized the Rapid Transit Commission for its hiring of a large temporary staff and its delay in commencing construction. A group photograph of the survey's workmen, which included two dozen UC co-op students, and a stack of their blueprints and paperwork, published in the daily newspapers, could have silenced Seasongood.

ORIGIN OF CENTRAL PARKWAY

The premature naming of Central Parkway was occasioned by construction of a new Hamilton County Courthouse on the south side of the canal between Sycamore Street and Broadway. Preparing to order signage, in 1917, its architects asked the Rapid Transit Commission what the new canal boulevard would be named. The Park Commission, which had veto power per the conditions of the Bauer Act, rejected the Rapid Transit Commissioners' suggestion of "Taft Parkway" and defaulted to Kessler's

Cincinnati's Incomplete Subway

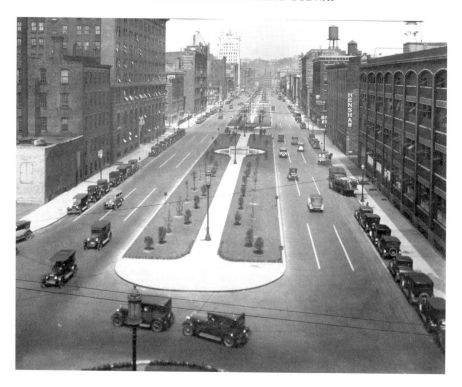

A 1928 view of the finished parkway looking east toward Mount Adams. *Courtesy of the City of Cincinnati.*

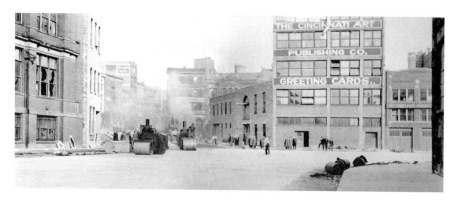

A 1927 view of paving at Eggleston Avenue. The block at center is presently a triangular parking lot. *Courtesy of the University of Cincinnati Archives & Rare Books.*

Central Parkway

View of the completed subway looking north from Liberty Street before construction of Central Parkway. *Courtesy of the University of Cincinnati Archives & Rare Books.*

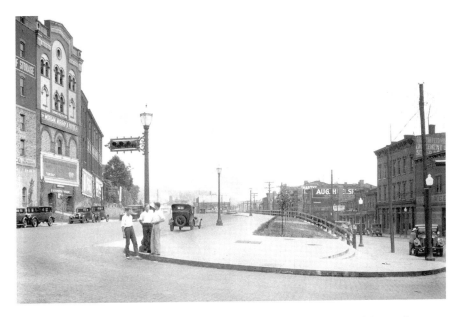

A 1928 view of Brighton Corner after completion of the Parkway. The Brighton subway station entrance can be seen at center. *Courtesy of the University of Cincinnati Archives & Rare Books.*

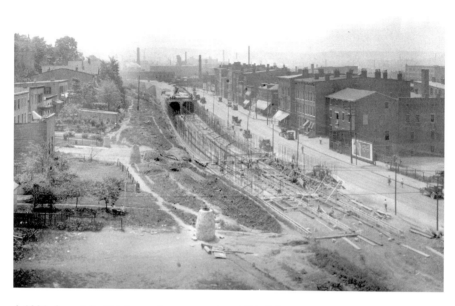

A 1926 view of the Brighton subway extension. All buildings in the right half of this photo were demolished in the early 1960s to permit construction of the Millcreek Expresssway. *Courtesy of the University of Cincinnati Archives & Rare Books.*

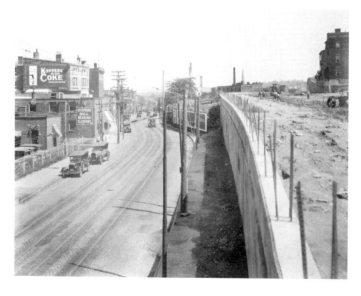

A 1927 view of Central Parkway under construction over the subway extension. Colerain Avenue and all of the buildings visible in the left half of this photograph were demolished for the Millcreek Expressway. *Courtesy of the University of Cincinnati Archives & Rare Books.*

title. By city ordinance, Canal Street and Plum Street north of the canal's elbow were retitled Central Parkway almost ten years before any work was undertaken.

The name was taken directly from earlier reports, which appear to have chosen it due to its proximity to Central Avenue. The generic name also insinuated importance and probably won it a few votes at the polls. But it also appears to have been a temporary name, and since its construction many efforts have been made to rename it after prominent figures, many of whom had no personal connection with Cincinnati.

THE PARKWAY IS FORGOTTEN

The city's focus on Central Parkway declined almost immediately after it was completed. It was soon understood that it would inadequately serve the planned cross-state turnpike, and that the new super road would require its own parallel path through undeveloped land near the Camp Washington Workhouse that had previously been eyed by the Cincinnati Reds as a new stadium site.

The claiming of the stadium site by the Millcreek Expressway forced the Reds to look elsewhere and delayed Crosley Field's inevitable demise for another generation. By the late 1940s, the favored stadium site had moved to the riverfront and, along with it, the grand civic buildings that fronted Central Parkway in earlier city plans.

Due to this shift, Central Parkway has received little attention since its construction and has simultaneously developed and declined in a haphazard fashion. Aside from construction of the Kroger headquarters in the 1950s, which was built on land owned by the Kroger Company since the late 1800s, the parkway section closest to downtown attracted zero development for seventy years. In the 2000s, several large buildings such as the former College of Applied Science were redeveloped into condominiums, and the Gateway Condos and parking garage were built at Vine Street, the first new construction on the north side of the parkway in seventy five years. The 2008–2010 construction of a new School for Creative and Performing Arts between Race Street and Elm Street signaled a return to the 1920s "civic mall" concept.

North of the elbow, no prominent new building has been built since the 1960s. For five years, the Millcreek Expressway interchanged directly with the parkway near Clifton Hills Drive, and during that brief period several low-rise motels were built on undeveloped land north of the Western Hills

This conceptual drawing illustrates construction of an expressway in place of Central Parkway. *Courtesy of Ohio-Kentucky-Indiana Regional Council of Governments.*

Viaduct. After Interstate 75 opened in late 1963, the entire parkway was bypassed, and this "Route 66" section took on a seedy character. As of this writing, plans for Interstate 75's reconstruction have not been made public. Redesigned interchange ramps might bring more traffic and more investment to the parkway, but a fundamental improvement will not occur until the subway is activated.

CHAPTER 10

BURYING THE SUBWAY

When subway construction began in 1920, it was announced that the Rapid Transit Loop, to whatever extent it could be built with the 1916 $6 million bond issue, would be completed and operational by 1925. But delayed bond issues and technical and legal issues in Brighton and St. Bernard meant that construction of contracts seven, eight and nine did not commence until 1926. Construction of the final section of the loop between St. Bernard and Oakley coincided with the beginning of physical work on Central Parkway. Included as part of the Central Parkway project and built in 1926 and 1927 were the short Hopple Street subway tunnel and an extension of the canal subway north from Brighton, including the portals still visible from I-75.

THE BOSS COX REPUBLICAN MACHINE

Amid this variety of road and railway construction, in January 1926, Cincinnati's municipal government experienced an instantaneous and nearly complete turnover of elected officials and staff. City Hall, county government and some state representatives of southwest Ohio had since the 1880s been controlled by the Republican political machine built and administered by George "Boss" Cox. The machine is believed to have influenced the conditions of the 1911 canal lease and the language of the Bauer Act, and the machine-appointed Rapid Transit Commission made the

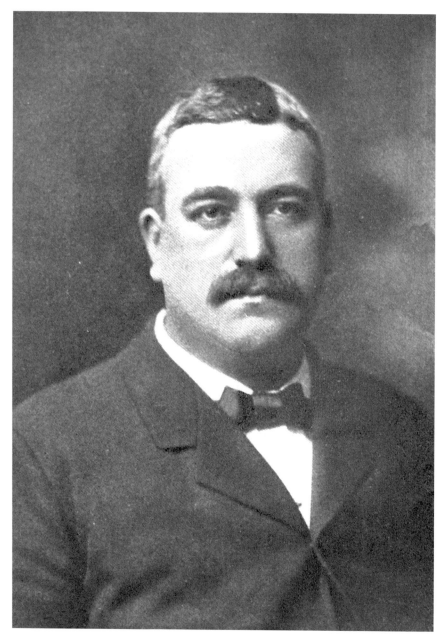

George "Boss" Cox. *Courtesy of* Bossism in Cincinnati.

Burying the Subway

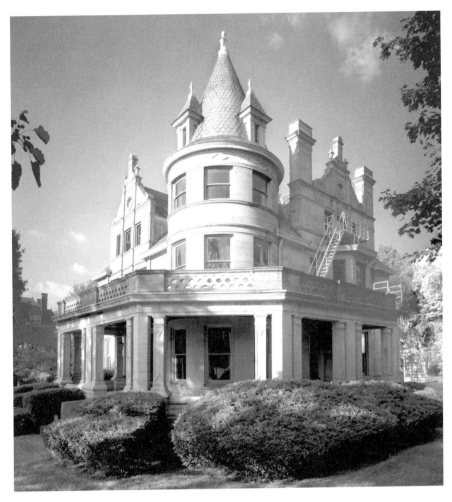

Parkview Manor, the mansion built by Boss Cox on Jefferson Avenue in Clifton, served for more than fifty years as a Pi Kappa Alpha fraternity house. In the upcoming decade, it is planned to become the Clifton branch of the Cincinnati-Hamilton County Public Library. *Courtesy of the author.*

decision to allow contracts for subway construction after the Ohio Supreme Court tossed out Ordinance 96-1917.

The Cox Machine maintained control by maintaining an avuncular public image. At times, Cincinnati's thirty-two-member city council was comprised mostly by bartenders, and Cox, himself a former saloonkeeper, famously blocked enforcement of Ohio's Sunday liquor laws. Top men under Cox were August Hermann, who owned the Cincinnati Reds between 1902 and 1927, and Rudolph Hynicka, who was part owner of Coney Island Amusement Park and its horse track.

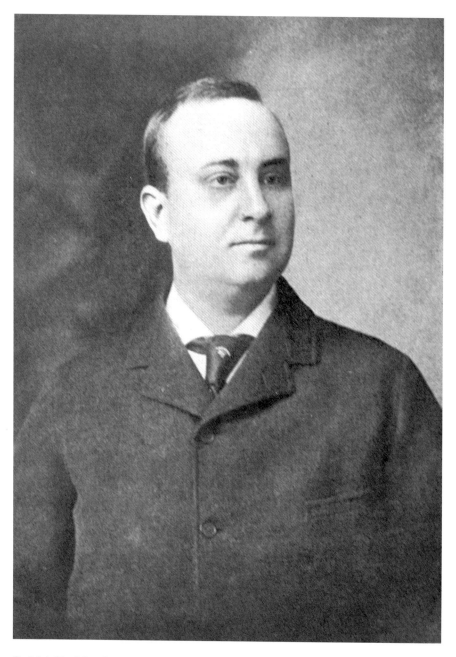

Rudolph Hynicka. *Courtesy of* Bossism in Cincinnati.

Burying the Subway

Murray Seasongood and the Charter Reforms

In the early 1920s, a group of young Republicans, led by local attorney Murray Seasongood, challenged and, after a two-year campaign, drove the Republican Machine out of City Hall. Whereas the machine's officers and ward captains celebrated their humble origins, freely advertised their lack of formal educations and presented themselves variously as Catholic or Protestant to suit the demographic of each ward, Seasongood was born to a prominent Jewish family, was raised in a mansion on East Eighth Street facing Piatt Park, attended boarding school in England and earned undergraduate and law degrees from Harvard University.

Unlike previous reform attempts, which confronted the machine while it was at full strength, in 1923, the organization was in crisis. After George

Murray Seasongood.
Courtesy of University of Cincinnati Archives & Rare Books.

Cox's death in 1916, control of the machine shifted to Rudolph Hynicka, who in 1917 moved permanently to New York City where he managed a chain of burlesque theaters. From this outpost, he still controlled Cincinnati government and "The Coney Island of the West" while living a short subway ride from the original Coney Island.

When Cincinnatians asked why they paid the highest tax rates permissible under Ohio law, and why their city was in more per capita debt than any other city in the United States, the machine pointed to the new Waterworks and General Hospital, its two greatest civic projects until Central Parkway and the Rapid Transit Loop. By the early 1920s, General Hospital alone had come to pinch municipal finances to the tune of $600,000 annually, and interest on Rapid Transit Loop bonds cost the city nearly $1,000 per day.

Meanwhile, city income was inhibited by a variety of unscrupulous activities: property assessments were cooked for party members, and fees and fines of all kinds found their way into the pockets of patrons instead of the city treasury. The situation promised to come to a head in 1925, when a state law permitting Ohio's cities to levee an additional 2.5 mills above their 10.0-mill maximum property tax was scheduled to expire, reducing Cincinnati and the machine's annual income by approximately $1,800,000.00.

After 1915, the machine annually filled budget shortfalls with special bond issues, and the November 1923 emergency bond campaign provided an event around which Seasongood's reform attempt could be rallied. The first move toward that end was made October 9, 1923, when Seasonood's debut political speech, printed in all three daily papers and dubbed by Seasongood himself "The Shot Heard Round the Wards," railed against this bond issue. His speech made this mention of the Rapid Transit Loop project: "What is to come of the rapid-transit plan? Ask anyone on the street, and he will shrug his shoulders. Ask the officials of the city. They do not know."

The November 1923 bond issue, which would not have funded the Rapid Transit Loop, failed along with the second attempted Central Parkway bond issue. The margins of defeat were so great that they would have failed even without Seasongood's efforts, but he made certain that he was popularly identified with their failure.

Throughout 1924, Seasongood built a case for his reforms, which prescribed institution of a city manager form of government, a weakening of the mayor and reduction of the number of city councilmen from thirty-two to nine. This last feature was important: a nine-member council selected by proportional representation promised to send the machine's thirty-two ward captains into a fit of infighting. These ward captains were pillars of

Ward captain Mike Mullen sells Coney Island picnic tickets to neighborhood boys. *Courtesy of* Bossism in Cincinnati.

the community. The best known, Mike Mullen, captain of the Eighth Ward, held an annual picnic at Coney Island that, at its peak of popularity, drew over twenty-five thousand. He, like many others, provided the poor of his ward with coal as winter and the November elections approached and then paid them between ten cents and a dollar as they walked to the polls.

The ballots themselves were tipped in favor of the two national parties; bird emblems were printed next to Republican and Democrat candidates for the benefit of the city's illiterate, but the names of independent candidates or nonpartisan charter amendments were "birdless." Seasongood drew attention to his nonpartisan ballot issues in 1924 with his "Birdless Ballot League," an organization that campaigned for his charter reforms throughout the year, including the late summer while he toured Europe for two months. Despite Seasongood's conspicuous absence and the presence of two decoy charter amendments placed on the ballot by Hynicka, the charter reforms that reshaped municipal government and are still largely in effect today passed by a 2–1 margin.

The new charter did not take effect for a year, and the subsequent orchestration of a Charterite takeover was helped by Central Parkway's complicated preparatory work. Throughout 1925, a team of surveyors and lawyers were busy defining the parkway's tax assessment zone for sixteen thousand assessed properties. Seasongood made the poor condition of the city's streets a major part of his argument against the machine; a completed Central Parkway would have dazzled the public and diffused his argument. The parkway could have been completed by 1925 if the 1921 bond issue had passed, but eighteen months after the electorate finally approved parkway bonds in spring 1924, there was no construction activity.

Seasongood and the Charterites take power

Little more than two years after his "Shot" speech, in November 1925, Seasongood and five other Charterites were elected to the new nine-member council. In order to secure power and fend off the machine in the long term, they had to make their campaign promises a reality—to the detriment of the Rapid Transit Loop. The new government was able to improve city finances quite easily by simply collecting all property taxes, fees and fines and eliminating patronage staff. They were able to carry out long-delayed projects such as installing new street signs and traffic signals while reducing the city's debt for the first time since 1915. Additionally, the image of

Seasongood and the Charterites was helped immeasurably by projects they had nothing to do with: the new Eight Street Viaduct was built by the state, and work on Central Parkway began just months after they took power. This all-new government had no direct control over the Central Parkway project or the Rapid Transit Loop project since the Rapid Transit commissioners, all machine Republicans, served ten-year terms.

Work continued on the Rapid Transit Loop in Bond Hill and Norwood, but by 1926, it had crossed a financial Rubicon: raising capital to complete the loop was one matter, but the specter of perpetual operational subsidies was another. This situation complicated the task of administrating the project, since the commission was in charge of finishing the Rapid Transit Loop and negotiating its lease, while city council would have to approve an operations budget, an eventuality for which no provision existed in the Bauer Act. This task would therefore require cooperation between the Charterites on council and the elected and appointed Hynicka-controlled members of council and the Rapid Transit Commission. Instead of working to build such coalition, Seasongood picked a headline-grabbing fight that stalled the project for the duration of his four year mayorship.

SEASONGOOD VERSUS THE RAPID TRANSIT COMMISSION

The charter reforms reduced the power of mayor to that of an ordinary councilman with no veto powers. The mayor was not elected directly and was instead selected behind closed doors by a caucus of his fellow councilmen, a process designed to intrigue the public. Seasongood, despite finishing second in voting, predictably emerged victorious and, upon taking office in January 1926 with the backing of his 6–3 majority Charterite council, immediately set about cleansing City Hall of all old Republican appointees. This was accomplished by eliminating city departments, then ordering the newly instituted city manager to create a replacement department with a new name and new staff.

First to be eliminated was the City Engineering Department, including chief engineer Frank Krug, whose home stood immediately next to the famous Boss Cox mansion on Jefferson Avenue. Krug had been an integral part of both the Rapid Transit Loop project and the planning of Central Parkway but had long been the object of criticism for having drawn a $4,000 salary as a Rapid Transit commissioner in addition to his $6,000 salary as chief engineer.

The only office protected by state law from Seasongood's purge was that of the City Auditor. Seasongood periodically lobbed mud at auditor Alfred Deckebach but directed most of his energy toward dissolving the Rapid Transit Commission—or rather drawing out its dissolution. Theoretically, the commission could have been dissolved instantly by city ordinance and the administration of the Rapid Transit Loop and Central Parkway projects passed to the Office of the City Manager, but Seasongood drew out the dissolution process for three years in order to build a narrative in the press in which he could repeatedly position himself as a hero of the people.

First, the Harvard Law graduate announced that per the language of the Bauer Act, three of five commissioners had served illegally since the failure of the Central Parkway bond issues. This was followed by an effort to strip the commissioners of their salaries and even order them to pay back what salaries they had drawn since their appointments. Neither action was of much legal merit, but Seasongood won the war by keeping these battles

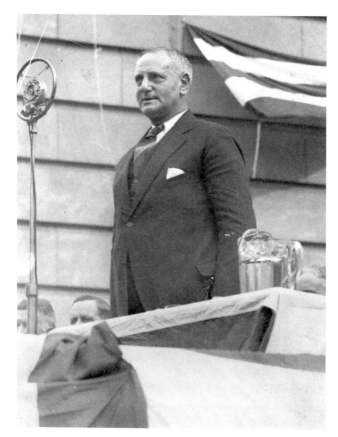

Mayor Seasongood speaks at Central Parkway dedication ceremonies in 1928. *Courtesy of the University of Cincinnati Archives & Rare Books.*

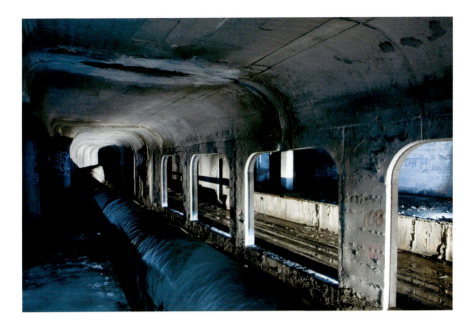

View of Brighton Station and water main, looking north from inbound platform. *Courtesy of the author.*

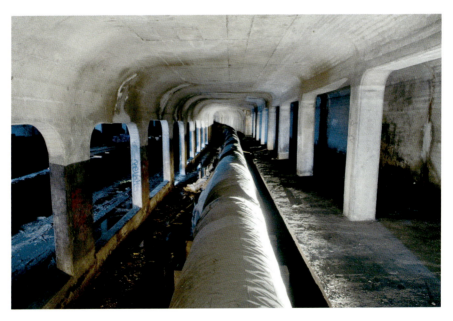

View of Brighton Station and water main, looking south. *Courtesy of the author.*

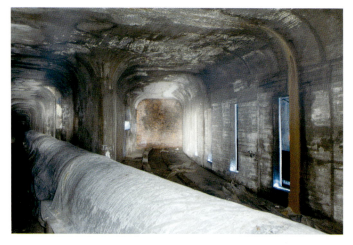

View of the Walnut Street turnout stubs, *center*, and the east interurban wye, *left*. *Courtesy of the author.*

View of the Hopple Street tunnel's sealed north portal. *Courtesy of the author.*

View of the decontamination showers installed in the Liberty Street Station's outbound platform concourse in the early 1960s. *Courtesy of the author.*

View of bunks installed in the Liberty Street Station as part of its conversion into a bomb shelter. *Courtesy of the author.*

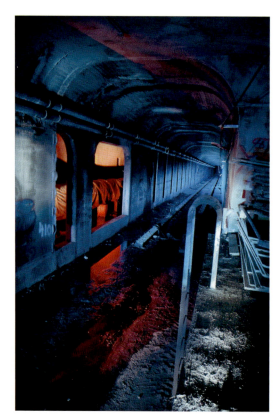

Above: View looking south on the Liberty Street station's outbound platform. *Courtesy of the author.*

Left: View looking north from the Liberty Street station's outbound platform. *Courtesy of the author.*

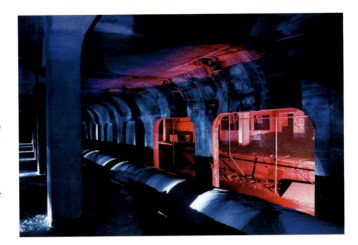

Looking across the station tracks from Liberty Street's inbound platform to the bomb shelter built on the station's outbound platform. *Courtesy of the author.*

Looking up the Liberty Street Station's east sidewalk staircase. *Courtesy of the author.*

Looking west across the Race Street station's island platform. *Courtesy of the author.*

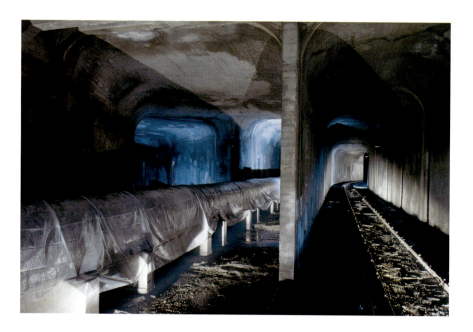

View of the Race Street station's west wye, left, and the subway's turn at Plum Street. *Courtesy of the author.*

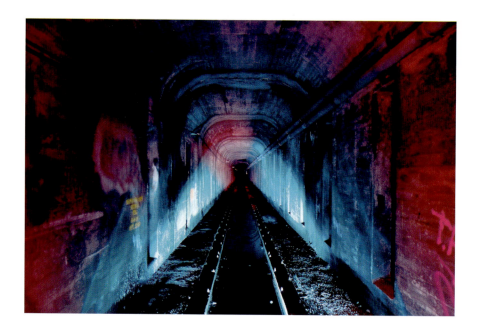

View of the subway's outbound tube, looking south just south of the Liberty Street station. Fiber optic cables were installed in 2000. *Courtesy of the author.*

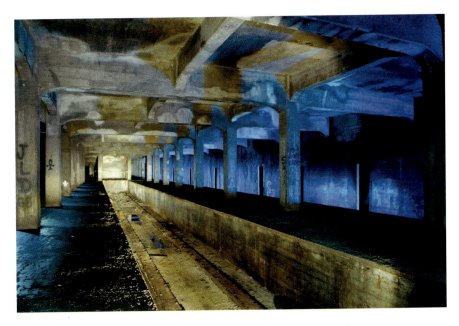

View of the Race Street station's center layover track. *Courtesy of the author.*

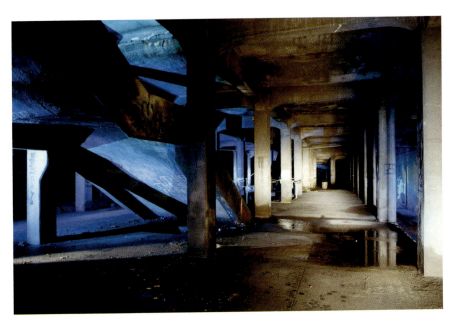

View of the Race Street station's center platform, looking west. *Courtesy of the author.*

Left: The high pressure water main installed in the subway's inbound tube in the late 1950s shoots water onto the Liberty Street station platforms. *Courtesy of the author.*

Below: View looking north from the Race Street Station's west wye. Elm Street is to the right and the subway's Plum Street turn is to the left. *Courtesy of the author.*

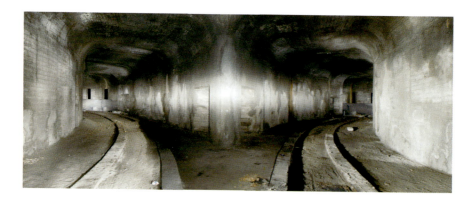

in the news for the duration of his first two-year term. He presented his accusations as having been proven true even after they had been discredited by the courts, steadily turning the public against the rapid transit project and quieting calls for its timely completion.

Having defeated the Republican machine in part by criticizing the absurdity of Hynicka's long absences from the city, during his first term Seasongood shamelessly left town to tour cities coast to coast espousing the city manager form of government. These speeches were reported in the papers of tour cities and then wired to Cincinnati papers, where his "good government" shibboleths and predictable railings against the Rapid Transit Commission were repeated yet again to local readers. On May 13, 1927, the *Cincinnati Daily Times-Star* printed a dispatch from Atlanta, where Seasongood, at a "mass meeting in the City Auditorium," chronicled the perfidies of the Rapid Transit Commission. The paper printed a verbatim account of this part of the speech, which likely took no more than two minutes to deliver, but nothing from the rest of his appearance.

THE BEELER REPORT

With work on Rapid Transit Loop contracts seven, eight and nine underway well out of sight of City Hall in Bond Hill and Norwood, in early 1926, council considered the merits of a completely separate streetcar subway project known as the "Broadway Subway," which would have seen Gilbert Avenue and Reading Road streetcars redirected into a new tunnel beneath Broadway south of Ninth Street. After a station at Seventh Street, the tunnel was to curve under Fifth Street to a terminal station under Government Square. This was planned in conjunction with a widening of Broadway that would have required demolition of all buildings on the east or west side of the existing street.

Theoretically, this terminal station could transfer passengers to the Rapid Transit Loop's future station beneath Walnut Street, and its phony cheerleaders advertised that fact, but Seasongood had no intention of pursuing construction of either tunnel. Avoiding all risk, he and others sought political shelter by commissioning a new report to recommend what should be done with the incomplete rapid transit line. This study, known as the Beeler Report, was a stall tactic and one devised to weaken the case for the loop.

The Beeler Report ignored any potential expansion of the rapid transit line beyond its original conception, most obvious being a northern branch

Present-day aerial view of the former Cincinnati, Milford & Blanchester interurban right of way near Merriemont. The bankruptcy of the CM&B and other interurbans was used to argue against completion of the Rapid Transit Loop; however, streetcar transfers were always expected to comprise the majority of the loop's ridership. The CM&B was purchased by the Cincinnati Street Railroad, and streetcar service to Marriemont continued until 1942. *Courtesy of the author.*

The Beeler Report recommended completion of the line to Fountain Square and Madison Road in Oakley, construction of an elevated Knowlton's Corner station and abandonment of the Liberty Street, Marshall Avenue and Clifton Avenue stations in order to increase speed. *Courtesy of the Beeler Report.*

on the canal, which was now in disuse to Lockland. Instead it prioritized service from the yet-unbuilt stations in Norwood and Oakley over those that had already been built—namely Liberty Street, Marshall Avenue and Clifton Avenue—so that rapid transit trains could beat the travel times of

Burying the Subway

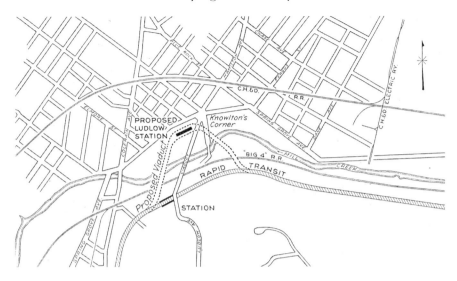

The Beeler Report recommended an elevated station for Knowton's Corner. *Courtesy of the Beeler Report.*

shorter streetcar lines from those distant points. The thought of bulldozing never-used surface stations, as was intended, upset the public, as did not using the Liberty Street Station, which was in the center of the most densely populated neighborhood in the Midwest.

Thinly veiled antisubway critiques of the Beeler Report began describing the Rapid Transit Loop as "circuitous," insinuating that it was planned poorly from the beginning. Other language acted to cast suspicion on the safety of fast operation of the line's trains and skepticism that the city's streetcars could operate in the tunnel, when their use was suggested in place of purpose-built rapid transit trains. Seasongood was quoted as saying he was told by those who prepared the report that Cincinnati was "not big enough for a subway," despite its population having grown 20 percent since the Arnold Report. After the Beeler Report's completion and presentation, Seasongood complained that since the city manager was not involved in creating the report that yet another study was needed that directly involved his city manager.

Seasongood was reelected for a second two-year term in November 1927. With the Central Parkway project complete and the $6 million Rapid Transit Loop bond issue exhausted before contract nine (the stretch between Norwood and Madison Road in Oakley) could be built, an ordinance was passed by council that called for the Rapid Transit Commission's

dissolution. On January 1, 1929, the commission ceased to exist and all matters relating to the subway and Rapid Transit Loop shifted to the Office of the City Manager.

A second report was completed in 1929 by the Beeler Organization in conjunction with the Cincinnati Street Railway, studying the feasibility of streetcar operation between Ludlow Avenue and downtown on the completed Rapid Transit Loop right of way. This second Beeler Report was relatively simple and took advantage of the line's strengths, whereas the first Beeler Report, by emphasizing the loop's weaknesses, intentionally created a proposal with problematic features that could be exploited by Seasongood.

This 1929 streetcar plan came relatively close to fruition. The Cincinnati Street Railway purchased streetcars that could serve the subway's high platforms, and the Cincinnati & Lake Erie, the only surviving interurban, purchased several interurban cars with a similar feature. Dual-gauge track was installed at the Winton Road streetcar barn, but since the plan was scuttled by the onset of the Great Depression, the broad-gauge axles on these streetcars and interurban cars were never sawed down, and the standard-gauge tracks at the car barn were never used.

The Walnut Street Tunnel

Seasongood's refusal to move forward with the rapid transit project was surely motivated in large part by the unknowns surrounding the Walnut Street Tunnel. Having seen cut-and-cover subway construction first-hand while attending high school in London in the 1890's, in Boston for seven years at Harvard University, and while working in New York City as a law clerk, Seasongood more so than other Cincinnati politicians knew that the chaos of subway construction was ripe territory for a revival of Hynicka's machine.

Whereas the subway beneath Central Parkway was the least expensive subway per foot in the country, the Walnut Street Tunnel would be as difficult and expensive as any in New York or Boston. As construction of this short but difficult tunnel would require approximately two years and inevitably overlap an election, the work in Walnut Street would provide a stage for Hynicka to politically sabotage Seasongood and the Charter movement. A month before elections, Hynicka's goons could have employed any number of tactics to embarrass Seasongood, ranging from staging strikes to causing a building to collapse.

Failure to move forward on the Walnut Street tunnel meant that the existing tunnel, with its terminus a half mile north of the business district, was useless. All subsequent efforts to use the subway have been hampered by its unfortunate terminus on the edge of the central business district.

Did the Charter Reforms Kill the Subway?

To borrow a cliché from today, from the perspective of the Republican Machine, the Rapid Transit Loop was too big to fail. The machine built the new Cincinnati Waterworks in 1907 and General Hospital a decade later; Central Parkway would at last realize a dream envisioned for generations and go a long way toward rebuking complaints about the poor condition of the city's roads. The subway beneath signaled that the machine could execute large, forward-looking and equitable improvements that were the envy of larger cities such as Detroit, Cleveland and St. Louis.

Subsidizing operation of the Rapid Transit Loop would not have presented a moral dilemma for Rudolph Hynicka. It was a concept with which he was intimately familiar since New York City, where he resided, for political reasons held subway fares to a nickel in the 1920s while streetcar fares in Cincinnati and most of the country rose to between seven and ten cents. New York's artificially low fares caused political turmoil in the rest of America's cities—populations nearly rioted in protest of streetcar fare increases in their respective cities, but they were equally upset by the prospect of subsidizing the for-profit traction companies.

But if Hynicka had remained in control, completion of the Rapid Transit Loop, or at least operation of part of it, was not an absolute certainty. Cincinnati was already scraping its debt ceiling, and if the struggle to pass bonds for Central Parkway was any indication, a similarly frustrating fight might have been in store for subway bonds. Meanwhile, except in New York City, where subway lines continued to be built to replace unpopular elevated lines, subways generally fell out of favor elsewhere. Cities that had been considering rapid transit subways were spooked by the unprofitable outcomes of the first New York, Boston and Philadelphia lines, and although they were built to reduce population density by opening up new territory, they actually acted to increase it.

The larger issue is that the financial strain placed on the city by completion and operation of the Rapid Transit Loop would pinch the machine's unofficial patronage budget. The machine began losing its grip in the early

Murray Seasongood, left, and Colonel Sherrill, Cincinnati's first city manager, are pictured in this mosaic installed in Union Terminal in 1933. *Courtesy of the author.*

1920s in part due to annual obligations to General Hospital; operation of the loop would aggravate the situation. The Rapid Transit Loop, had it been put into operation, might even have caused the collapse of the machine in the 1930s, as the drop in tax revenue caused by the Great Depression would have dropped potential payouts.

The charter reforms did not single-handedly defeat the machine; Rudloph Hynicka's health was poor throughout the two-year reform movement, and he died in early 1927, hardly more than a year after Seasongood took over. A parallel effort to reform county government begun in 1926, known as the Citizen Movement, failed to enact a new county charter, but it meant that the vestiges of the machine, accustomed to fighting one uprising at a time, had to simultaneously battle to maintain its control of county government while plotting a City Hall comeback. August Hermann died four years after Hynicka, and with diminished income during the Depression, the lack of tax income available for patronage discouraged a revival of the machine.

Murray Seasongood's Legacy

While Seasongood was entirely justified in his overall criticisms of the machine, there is no evidence or that a significant sum of money disappeared in the administration of the loop project by the Rapid Transit Commission. Hynicka's machine was in financial crisis but needed the Rapid Transit Loop to be a success. If money did in fact disappear, the machine shifted other funds into the account in preparation for the Charterite takeover. "The Report of the Rapid Transit Commissioners," ordered by Seasongood upon taking office, gives a believable account of the management of both the Rapid Transit Loop and Central Parkway projects.

Seasongood's strategy, clearly intended to stall the subway project, probably did not intend to completely kill it. Piecing together Seasongood's words and actions, he was setting the stage for the subway project to be "saved" by him, completed on his terms and then become his victory. But because Union Terminal and the Carew Tower broke ground during his tenure, he didn't need the subway as a short-term political win. He could not have predicted that automobile use would continue to rise at an exponential rate or that the country would sink into its worst financial period just as he was leaving office. He could not have predicted that, aside from Chicago's State Street and Dearborn subways, which merely supplemented that city's famous elevated loop, a new rapid transit subway system would not be built

anywhere in the United States until San Francisco's BART broke ground in the mid-1960s.

Seasongood and the Charter Movement do deserve credit for turning around the city's finances in short order. Between 1926 and 1940, Cincinnati shifted from being the country's most indebted to its least indebted city. Revenues were enhanced a favorable renegotiation of the Cincinnati Southern Railroad lease in 1928 and expenditures were slashed by eliminating dozens, if not hundreds, of redundant patronage jobs and ending the practice of securing patronage by paying contractors for work never performed. These increases in revenue and savings were so dramatic that the City of Cincinnati could have easily afforded the construction of the entire sixteen-mile Rapid Transit Loop and operated it at an annual loss of $1 million or more.

But by the late 1930s, when these savings were realized, the subway faced new challenges. Plans advanced for a cross-state turnpike on the canal right of way, placing the state's bulldozers on a collision course with the city's Rapid Transit Loop. Meanwhile a change in state law required 65 percent supermajorities for local bond issues, taking the wind out of a subway revival effort. With no local funding to complete the loop, Cincinnati was nearly helpless to stop its destruction.

CHAPTER 11

STREETCAR AND FREIGHT SUBWAY PROPOSALS

In July 1929, the Beeler Organization completed a second report titled "A Report to the Cincinnati Street Railway Company on a Rapid Transit Line Between Central Parkway and Race Street and Ludlow Station, Cincinnati, Ohio", which discussed the feasibility and finances of what amounted to a rapid transit shuttle between Downtown and Knowlton's Corner. Four-minute headways throughout the day promised to replace a twenty-five-minute streetcar ride with a nine-minute subway ride and attract 37,000 daily riders.

The report discussed no major modifications to the line such as a Walnut Street tunnel or elevated station in Northside, but did recommend the abandonment of the Marshall Avenue station and construction of a two-mile nonrevenue track on the Rapid Transit Loop northeast from Ludlow Avenue to reach the Winton Road streetcar car barn. This service track could of course have been utilized if service was extended to St. Bernard. Part of it would be used immediately by the CL&E, which survived the interurban meltdown and in the late 1920s purchased new "Red Devil" cars designed for use in the subway.

The report did not discuss how many rapid transit cars would be purchased, but since two trains were to operate in each direction at all times at a maximum length of three cars, no more than fifteen cars were necessary to begin service. According to several accounts, this plan was very close to fruition, and duel-gauge tracks were even installed at the Winton Road car barn. The report was released just three months before

the October stock market crash, after which time capital was unavailable for this relatively small project and use of rapid transit trains was never again proposed for the Rapid Transit Loop.

STREETCAR SUBWAYS

Revival of subway proposals in Cincinnati appears to have been spurred by the 1935 opening of Newark, New Jersey's "City Subway", which was also built in place of a canal but used unmodified streetcars instead of rapid transit trains. A special section in *The Cincinnati Enquirer* printed photos of similar views of each city's transit lines side-by-side, some of which bore an uncanny resemblance.

By coincidence, two subway studies were completed in 1936. The first, by the City Engineer's Club, was not an official study. It suggested use of the Rapid Transit Loop right of way and the two-mile subway tunnel beneath Central Parkway by streetcars, and a downtown streetcar terminal beneath the Court Street Market, where passengers could transfer to electric

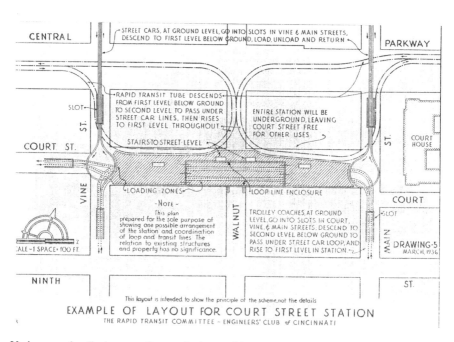

Underground trolleybus transfer terminal as envisioned by the City Engineer's Club in 1936. *Courtesy of the Enginneer's Club.*

Streetcar and Freight Subway Proposals

trolleybuses that would circle downtown streets in perpetuity. According to critics, the inconvenience associated with the modal transfer and the slow movement of the trolleybuses threatened to destabilize downtown property values in favor of the Court Street terminal.

The 1936 "Cincinnati Transportation Survey," funded by the Works Progress Administration (WPA), is the more interesting of the year's two reports. Its survey of streetcar ridership patterns, collected by a crew of seventy men who rode the city's streetcars every weekday for three months, provided hard data for an application for New Deal capital funds. The report recommended use of the Rapid Transit Loop by streetcars, including

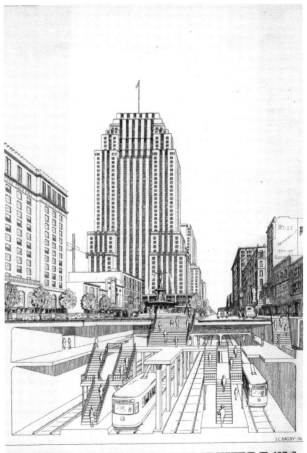

The "City Subway" Fountain Square station. *Courtesy of the 1936 Cincinnati Transportation Survey.*

Cincinnati's Incomplete Subway

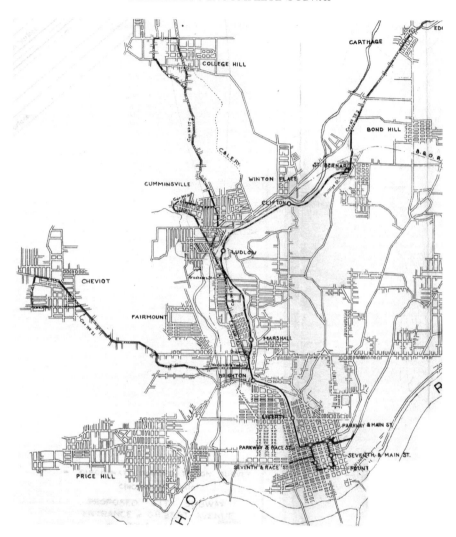

City subway map. *Courtesy of the 1936 Cincinnati Transportation Survey.*

the Central Parkway Subway, as far north as St. Bernard, and construction of a streetcar subway loop in the downtown area similar in concept to the downtown loop proposed by Bion Arnold in 1912.

The so-called "City Subway" was to consist of a double-track loop built under Race Street, Main Street and Fifth Street. Streetcars would enter the loop through the existing Central Parkway subway and several other entry points and circle either the inside or outside track. Stations would be built with center island platforms in order to allow cross-platform transfers, but

Streetcar and Freight Subway Proposals

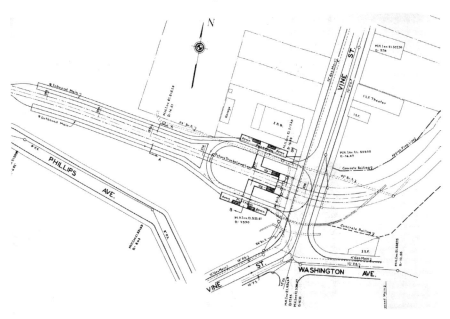

Elevated turnaround in St. Bernard. *Courtesy of the 1936 Cincinnati Transportation Survey.*

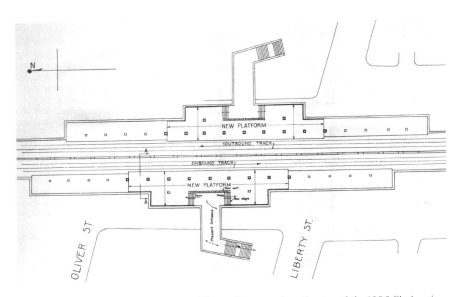

Liberty Street platform modifications, Liberty Street station. *Courtesy of the 1936 Cincinnati Transportation Survey.*

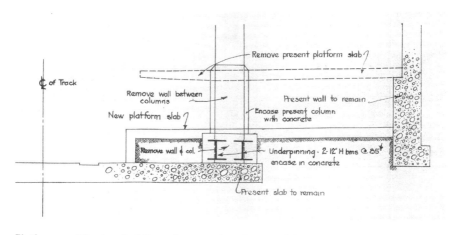

Platform modifications in Liberty Street station. *Courtesy of the 1936 Cincinnati Transportation Survey.*

because all of the Cincinnati Street Railway's streetcars had doors only on the right side, flying crossovers were planned inside each portal to direct streetcars to the left-side loop track.

The study divided discussion of the City Subway and "Use of Rapid Transit Facilities" into different sections and recommended the funneling of various streetcar lines onto the Rapid Transit Loop route. College Hill and Northside streetcars would join the Rapid Transit Loop at a point just south of Ludlow Avenue, and Western Hills Viaduct streetcars would join the existing subway just north of Brighton. The Liberty Street and Brighton Stations would have their platforms lowered for use by streetcars, as would the Marshall Avenue, Ludlow Avenue and Clifton Avenue surface stations.

WPA Projects in Cincinnati

The 1936 Cincinnati Traffic Survey estimated the cost of the City Subway to be $4,457,035 and conversion and completion of the Rapid Transit Loop for streetcar service north to St. Bernard to be $1,563,420. Federal funding of 45 percent was possible, which meant a bond issue of at least $3,000,000 was required. It does not appear that the City Subway was part of Cincinnati's application to the WPA, and instead funding was sought and awarded for construction of Columbia Parkway and its Fifth Street Viaduct, which commenced construction in 1937. The time advantage promised by

the Rapid Transit Loop's unbuilt eastern half was claimed instead by the new parkway and its high viaduct over Eggleston Avenue.

New Deal funds were also awarded to build the basin's first public housing blocks. About $7 million—more than the subway proposal—was awarded to demolish several densely built blocks of nineteenth-century row houses and replace them with four-floor housing blocks. The entire West End south of Liberty Street and west of John Street, home to more than fifty thousand people, was demolished piece by piece over the next twenty-five years. The original Laurel Homes buildings were demolished in the early 2000s and replaced by City West, a mixed-income development that loosely mimics the area's original brick row houses.

The Supermajority Era

1939–1969

In 1939, just as political support for a downtown streetcar subway experienced a surge of support, Ohio drastically altered its election laws. In an abrupt departure from simple majorities, beginning in 1939 and until 1949, a 65 percent supermajority was required for major municipal bond issues, making construction of subways, expressways and airports nearly impossible anywhere in the state.

This change did not ice discussion of subway construction, perhaps because it was believed that the situation was temporary. In 1939, a new study advised a plan nearly identical to that described in the 1936 Cincinnati Traffic Survey but avoided its unusual left-track plan by substituting side-platform stations. Streetcars were still favored over diesel buses due to their ability to operate in tunnels without automated ventilation, which was estimated to increase construction costs by $2 million, or approximately 20 percent. Planners also favored PCC streetcars due to their higher passenger capacity, fearing that operation of an all-bus subway might cause traffic jams inside the subway and on the surface near its portal entrances.

It was announced in August 1940 that this downtown subway plan, which would have cost between $10 million and $13 million, would be submitted to the electorate in 1941. Some expected that a variety of road projects would be bundled with the subway as part of a bond issue totaling approximately $15 million. Cincinnati could easily afford this debt, as its total bonded indebtedness, was reduced by $20 million after the Republican Machine's

An Editorial
Invest for Good of City

CINCINNATI'S CREDIT is the best in the nation. Current bonds bear the remarkably low interest rate of 1.65 per cent. The city's indebtedness has been reduced by $20,650,000 since 1926. No city gets a bigger value for its tax dollar than does Cincinnati.

This favorable financial position does not invite any splurge or spending for the sake of spending, but it should encourage citizens to approve some prudent investing for vital public purposes, investing that will bring dividends.

Next Tuesday's ballot contains these bond issues:

$2,000,000 for more parks and playgrounds. We call this a gilt-edged investment for the health, happiness and safety of our children.

$2,000,000 for general street improvements. Keeping streets repaired is as essential as keeping the house painted. This money will enable the city to continue its orderly, 20-miles-a-year street building program.

$3,000,000 for better traffic approaches to Price Hill. These improvements are much needed from a traffic standpoint. Better highways will stimulate the residential and business development of Price Hill, a sound investment.

THE POST heartily recommends a vote FOR for these issues.

Debt editorial from the November 2, 1939 *Cincinnati Post*. Courtesy of the E.W. Scripps Company.

1926 ouster. But as world affairs deteriorated in 1941, the vote was postponed and then set aside as a "postwar project."

In 1949, the state-mandated supermajority was lowered to 55 percent, likely motivated by dozens of failed postwar expressway bond issues. In Cincinnati, failed expressway bond campaigns meant the 65 percent supermajority requirement gave the Rapid Transit Loop a few more years

Streetcar and Freight Subway Proposals

	Population	Net Debt	Realty Assessed Valuation	Gov'tal Costs
1934. Census figures are from 1930:				
CINCINNATI	451,160	$ 37,849,000	$ 804,088,000	$11,906,880
St. Louis	821,874	65,145,501	684,361,533	19,269,908
San Francisco	634,394	163,596,800	1,024,352,227	50,280,066
Milwaukee	578,249	39,712,433	851,791,430	29,145,989
Buffalo	573,076	86,541,143	969,222,560	41,992,560
Newark, N. J.	442,337	90,676,570	711,322,521	37,136,805
Kansas City	399,746	37,043,794	576,469,780	5,975,000
Rochester	328,132	63,339,692	633,827,915	23,827,915

1939 debt comparison graphic. *Courtesy of the E.W. Scripps Company.*

to sit unused. Meanwhile, the law directly affected the placement of the region's airport in Boone County. Numerous late 1940s airport bond issues won more than 50 percent of the vote but not the required supermajority, and as a result, property acquisition for a major airport in Hamilton County was never sufficiently funded and the region's airport lost to Kentucky. State law did not return to a simple majority until 1969.

SUBWAY DEBT REFINANCED

The various bond issues totaling $6 million sold between 1919 and 1925 were sold according to a fifty-year term dating from 1917 but were redeemable in its twenty-fifth year. In 1940, when the Cincinnati Metropolitan Transportation and Subway Committee advocated a large bond issue for construction of a downtown streetcar subway, it was expected that in 1942, the interest rate of Rapid Transit Loop bonds would be reduced from 5.00 and 5.75 percent to 2.50 percent.

Instead, the economic chaos created by the Second World War permitted the Rapid Transit Loop bonds to be refinanced at an exceptionally low interest rate of 1.25 percent. That year, refunding bonds scheduled to mature in 1966 replaced $4,440,000 of the Rapid Transit Loop's original bonds. A portion of the original subway bonds held by the Jacob Schmidlapp Trust were refinanced at 4.50 percent, which in a twist came to fund free summer concerts at the Murray Seasongood Pavilion in Eden Park. The inconsistent refinancing of the Rapid Transit Loop's bonds sparked rumors that the trustees of the Cincinnati Sinking Fund and Schmidlapp Trust conspired to keep the subway from being activated. On May 28, 1965, a letter to the *Cincinnati Post* asked:

It is our understanding that one of the largest brokerage concerns collects $350,000 a year from the city to pay dividends on outstanding stock issued when the project started. It is also said that as long as this subway lays idle, these dividends will continue, but if this project is ever used commercially, these dividends will stop. That seems to be the reason that anything is brought up to use this facility is discarded or voted down.

Freight Subway Proposal

With a downtown streetcar subway delayed indefinitely by the war, in 1942, a proposal appeared for the lease of the Rapid Transit Loop south of Ludlow Avenue for freight purposes. In 1943, a city ordinance was passed that described tentative terms for a lease of the subway, and the next year, twenty-six companies near the subway announced an interest in rail service. A group of area businessmen formed the Parkway Industrial Railroad Company, hired their own engineering firm to prepare preliminary drawings, and as a publicity stunt purchased a gasoline-powered locomotive that they claimed would be used in the subway.

Rails were to be laid five miles south from the B&O mainline tracks near the Ludlow Viaduct to the subway's Plum Street turn. Industries adjacent or near the subway would be served by various new spur tunnels built at its own expense. A single gasoline locomotive, purchased at auction in 1944, was believed to be sufficient to handle all of the freight subway's traffic.

The proposal was attacked on several fronts. The Cincinnati Metropolitan Transportation and Subway Committee argued that use of the subway by freight trains would complicate or possibly preclude its use by streetcars. Here the track-gauge gremlin appeared once more: the combined use of the tunnel by standard gauge freight cars and Cincinnati's broad gauge streetcars would require an additional pair of tracks to be laid outside each freight track. Speed of the streetcars would be limited by the many crossings of broad-gauge tracks across standard-gauge turnouts leading to new spur tunnels.

The freight proposal was next attacked on the grounds that, per the conditions of the Bauer Act from 1915, the City of Cincinnati could not lease the subway without its approval by the electorate. Therefore, for the first time in twenty-nine years, a subway matter was placed on the ballot, and in November 1946, Cincinnatians by a 2–1 margin approved a five-

Streetcar and Freight Subway Proposals

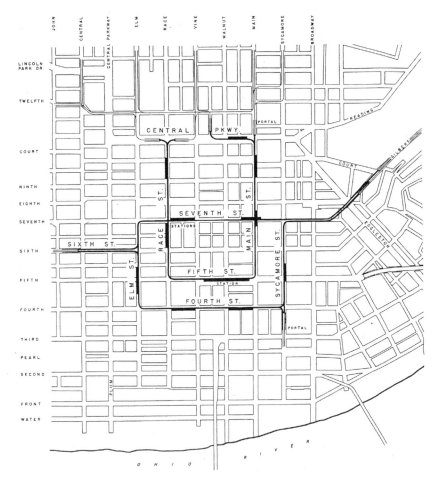

REPORT ON TRANSIT DEVELOPMENT—1947
POSSIBLE ULTIMATE SUBWAY LOOPS

In the late 1940s, subway proposals shifted to use by electric trolleybuses. *Courtesy of* Public Transit.

year lease of the subway to the Parkway Industrial Railroad Company for $32,000 annually.

But a lease was not signed and no tracks were laid. Clearly, the junction of the subway railroad and the B&O mainline was in conflict with plans for the Milllcreek Expressway. The unusual geometry of the area created

a situation that would have required a multimillion redesign of the Ludlow Viaduct in addition to an elevated expressway. Moreover, since the Millcreek Expressway was being built to improve truck access to Cincinnati's basin industries, the freight subway would have lost most of its business shortly after its construction.

CHAPTER 12

THE MILLCREEK EXPRESSWAY

In the mid-1920s, Ohio announced its intention to build and complete a cross-state turnpike between Cincinnati and Toledo by 1935. Most of the new roadway would be built in place of the Miami–Erie Canal, and in 1929, the state signaled its intention to use the completed but unused Rapid Transit Loop right of way by reducing Cincinnati's annual canal rental from $32,000 to $100.

This plan did not necessarily physically conflict with the Rapid Transit Loop, since per the language of the 1911 canal lease the railway was built north of Ludlow Avenue so as to accommodate the construction of a "boulevard." But the opening of the Western Hills Viaduct in 1932 overwhelmed Central Parkway's capacity and illustrated to all observers that extension of the parkway as planned north to Mitchell Avenue would provide a woefully inadequate entrance for the cross-state turnpike. Provision for the boulevard permitted a four-lane roadway—the same number of lanes originally planned for the Millcreek Expressway—but higher speeds enabled by straightening and regrading the route meant the Rapid Transit Loop's overpasses, surface stations and graded roadbed must be bulldozed.

Survey work for the turnpike was performed in 1931, but the Great Depression delayed any construction until 1941 and 1942, when a short two-mile section in central Hamilton County was built by the WPA to connect Galbraith Road with the Wright Aeronautical Plant. This so-called Wright–Lockland Highway formed a dividing point for future planning, both in name and in funding strategy. A state-built, limited-access toll road modeled

CINCINNATI'S INCOMPLETE SUBWAY

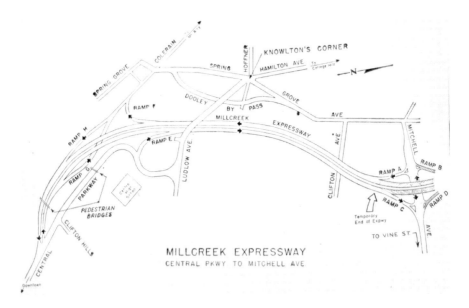

This section of the Millcreek Expressway was built directly in place of the Rapid Transit Loop's Section Six. *Courtesy of the City of Cincinnati.*

The Ludlow Avenue station is demolished in December 1955. *Courtesy of the E.W. Scripps Company.*

The Millcreek Expressway

after the Pennsylvania Turnpike was planned for north of the plant. South of the existing Wright–Lockland Highway, the cross-state turnpike's planned entrance into Cincinnati was dubbed the Millcreek Expressway and would not be funded with tolls.

South of Ludlow Avenue, Central Parkway would remain intact, and the Millcreek Expressway would be built through Camp Washington, Brighton and the West End en route to Fort Washington Way and a new Ohio River bridge. In the 1920s and through the 1930s, the Camp Washington Workhouse's excess property was seen as the site for a new baseball stadium. The Millcreek Expressway therefore unintentionally preserved Crosley Field for another generation but set the stage for the multipurpose Riverfront Stadium.

THE CINCINNATI SOUTHERN RAILROAD–EXPRESSWAY BOND ACT

Expressway construction in Ohio's cities was inhibited by a 1939 modification of state law that required 65 percent supermajorities for large municipal bond issues. The Millcreek Expressway and Fort Washington Way bond campaigns won majority but not supermajority approval in 1946 and 1948. The following year, two significant changes in state law opened the door for construction of the Millcreek Expressway and the bulldozing of the Rapid Transit Loop. First, bond issue supermajorities were reduced to 55 percent statewide, and then the Ohio state legislature, eager to build an expressway entrance into Cincinnati, helped the city fund its local share by passing the Cincinnati–Expressway Bond Act.

Previously, Cincinnati Southern Railroad income could only pay interest on municipal bonds. The new law expanded Cincinnati's bonding power by approximately $45,000,000 by permitting railroad revenues, including those additional annual sums totaling $600,000 made available after 1952 and 1959, to back the bonds themselves. A tax increase avoided, in 1950, Cincinnatians approved an expressway bond issue backed by railroad revenues that enabled construction of the Millcreek Expressway south from Paddock Road to Ludlow Avenue. The Ludlow Avenue and Clifton Avenue Rapid Transit Loop stations were demolished in 1953, and the Millcreek Expressway opened in place of the loop between Ludlow Avenue and Mitchell Avenue in 1957. The expressway's traffic was routed onto Central Parkway opposite Clifton Hills Drive, approximately four miles north of

downtown, until the Millcreek Expressway extension to Fort Washington Way and the Brent Spence Bridge opened in late 1963.

Technically, the bond act permitted railroad revenue to back work on any aspect of the 1948 Master Plan. One related document outlined vague future subway plans for a rapid transit line between eastern and western riverfront neighborhoods, with a subway under Fourth Street. It also proposed construction of subways under Plum, Vine and Sycamore Streets to form the "nucleus" of a regional rapid transit system; however, the nature of this network was not discussed.

FEDERAL AID HIGHWAY ACT OF 1956

During the late 1940s and early 1950s, the national lobbying effort for expressways funded by the automobile and oil companies pitted cities against each other. Newspaper articles reported which cities had just finished or funded large new expressways and warned that Cincinnati was "falling behind." The playing field was leveled with the passage of the Federal Aid Highway Act of 1956, which funded construction of the National System of Interstate and Defense Highways—to date the largest public works project in world history.

A 3-cent national gasoline tax enabled the release of $25 billion over twelve years for construction of over forty thousand miles of intercity expressways, but unlike the German Autobahn upon which it was allegedly modeled, the Interstate Highway System would not be tolled and would be built directly through cities. Overnight, completion of the Millcreek Expressway south from Ludlow Avenue to the Ohio River shifted from a 25/75 city-state funding formula to the 5/5/90 city-state-federal formula implemented nationwide. The $200 million expressway network drawn in Cincinnati's 1948 Master Plan would now cost the city just $10 million; it killed not just any sliver of hope for the Rapid Transit Loop but all U.S. rail public transportation projects, which received no significant federal funding for the thirty-year period stretching between the New Deal and the Urban Mass Transit Assistance Act of 1970.

With a local dollar able to build just one dollar of transit infrastructure but nine dollars of interstate highway, all American cities embarked on a frenzy of expressway construction. After 1956, no municipalities voted for them directly, and no urban expressways built after 1956 were tolled. A bottomless well of federal funds enabled the simultaneous construction of several

The Millcreek Expressway

2—The Post & Times-Star Cincinnati, Tues., May 2, 1961

X-Way for Subway

A DREAM CRUMBLES—The Marshall avenue station of the planned Cincinnati subway has been torn down to make way for a new plan to speed traffic from downtown Cincinnati. The Cleveland Wrecking Co. demolished the waiting station alongside Central parkway to make way for the Mill Creek Expressway.

The Marshall Avenue station is demolished in 1961. *Courtesy of the E.W. Scripps Company.*

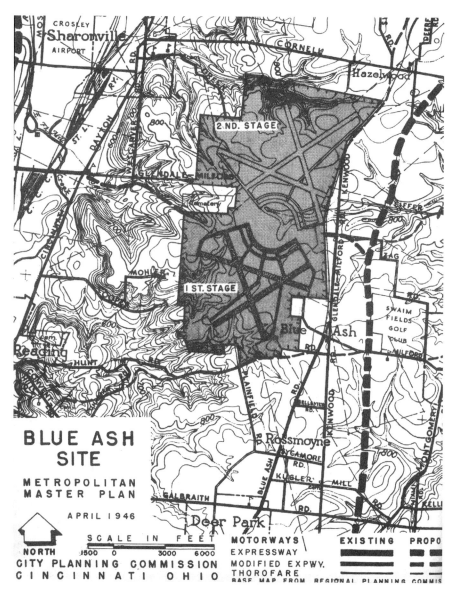

Plans for a major airport in central Hamilton County were blocked primarily due to Ohio's 65 percent supermajority requirements for municipal bond issues. By the time the supermajority was reduced to 55 percent in 1949, the region's airport had been lost to Boone County, Kentucky. *Courtesy of the Airports in the Master Plan, Cincinnati City Planning Commission 1946.*

The Millcreek Expressway

expressways in every city, and planners often began in the most densely populated areas. They knew that a backlash could develop, and that these critical city sections needed to be built before opposition could organize.

The Millcreek Expressway between Ludlow Avenue and Mitchell Avenue was designed and began construction before passage of the Federal Aid Highway Act. As it was not built to interstate highway specifications, it was partly rebuilt with emergency shoulders and new lighting in the early 1960s. A short gap through St. Bernard persisted for several years, meaning the Millcreek Expressway acted as a de facto Central Parkway as envisioned by George Kessler's 1907 parkway plan until the whole roadway, including the Brent Spence Bridge, opened in 1963.

At that time most Millcreek Expressway signage was removed and replaced by Interstate 75 shields, but at least one small "Millcreek Expressway" sign remained near Paddock Road until the early 2000s.

Little opposition to the demolition of the West End is documented in newspapers. All Cincinnatians had long-since been convinced that the West End was as nuisance, and children in Cincinnati Public Schools were in fact indoctrinated into that line of thought by literature included as part of local history classes. A booklet, "Cincinnati: Then & Now," published explicitly for Cincinnati Public Schools, derided the West End and all basin housing in favor of single-family suburban homes.

Mild opposition to the highways did form in the early 1960s, by which time mitigation of the Millcreek Expressway was a lost cause and attentions shifted to the Northeast Expressway. Between Norwood and Oakley, what came to be designated as I-71 was built directly over the route planned for the eastern half of the Rapid Transit Loop. One call to avoid its Walnut Hills routing suggested an O'Bryonville alignment instead, reviving the old Supplemental Tunnel Route.

Columbia Parkway could not be upgraded to interstate specifications, and I-71 was built as planned through Walnut Hills adjacent to the CL&N tunnel and directly over the Deer Creek Tunnel. Several calls were made to incorporate a rapid transit line into the center of I-71 as had been done recently in Chicago, but funding for such a project did not exist until 1976, after the expressway was completed. Two new overpasses were built for the CL&N over I-71 and a third over Victory Parkway, but the railroad ceased operating just two years later. The 2002 Metro Moves light rail campaign planned to reuse the double-track Victory Parkway overpass.

Bus Service on the Interstate Highways

The automobile and oil lobby argued to cities across the country that commuter bus service on planned expressways could serve the suburbs faster and with more flexibility than rail transit lines ever could. This was an economic impossibility because moving a set number of passengers farther required more buses and more drivers to provide the same frequency of service. Meanwhile, private bus companies were not exempt from the federal gasoline tax enacted in 1956, meaning they were forced to pay for new Interstate Highways years before they were able to benefit directly from them.

The Cincinnati Transit Company paid the new federal gasoline tax for seven years before it commenced service on the newly minted I-75 in November 1963. But ridership suffered severe declines in the preceding years due to the West End's demolition, which had, since the Civil War, been a dependable source of profitable operation. Buses now had to travel much farther to serve the same number of passengers because of new public housing projects on the city's periphery (where many West End residents were relocated) and the new, far-flung suburbs.

View of Crosley Field and Interstate 75 construction on opening day in 1962. *Courtesy of the author.*

The Millcreek Expressway

By 1965, the writing was on the wall, and public ownership became a major local issue. Unfortunately, the quality of Cincinnati Transit Company's service declined so markedly during this period and politicians attacked the company so vociferously that sentiment was turned against any and all public transportation. By the time Cincinnati voters approved a public takeover in 1973, opportunity for federal funding of a rapid transit subway system in Cincinnati had passed.

CHAPTER 13

ATTEMPTS TO REVIVE RAIL TRANSIT IN CINCINNATI

Public transportation ridership in the United States remained high through the late 1940s but plummeted precipitously after 1950. Complaints about excessive streetcar company profits heard in the century's first half, stoked and exploited by politicians, shifted to complaints about subsidies and service reductions, which were again stoked and exploited by politicians. After passage of the Federal Aid Highway Act of 1956, a local dollar bought nine dollars of highway but only one dollar of transit. Combined with state laws that prevented many municipalities from enacting dedicated transit taxes to cover operations costs, rail transit systems became nearly impossible to build.

The only American city to launch a new rapid transit network during the height of interstate highway construction was San Francisco, which joined with Oakland and surrounding counties to form BART in 1957. An act of the California legislature in 1958 permitted excess toll revenue from the Bay Bridge, where a profitable rail service had recently been removed, to back bonds for construction of a transbay subway tunnel. Upon this momentum, a $792 million multicounty bond issue, passed in its first attempt in 1962 by a 61 percent margin (a 60 percent majority was required by state law), funded seventy-one miles of rapid transit construction. Final design and construction of the system began with absolutely zero federal funding.

With BART under construction, manufacturers who stood to benefit from the construction of rapid transit systems lobbied Congress and state and

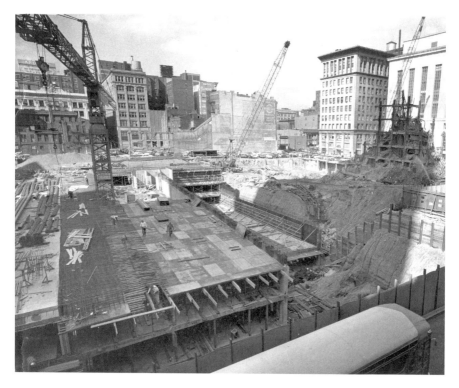

View of construction of the Fountain Square parking garage circa 1966. *Courtesy of the Noel Prowles Collection.*

local politicians with the intent to attract funds to construct systems in all American cities, including Cincinnati. The effort was led by General Electric, who along with steel, aluminum, rail car and rail parts manufacturers were successful in winning a small amount of federal funding for "mass transit," the era's catch phrase.

The Urban Mass Transit Act of 1964, initiated by President Kennedy and signed into law by Lyndon Johnson, permitted federal funding of up to 66 percent of local transit projects but was allocated just $150 million by Congress. This sum funded a variety of small projects such as extension of Cleveland's Red Line to Hopkins Airport, but it was insufficient to fund any new rail-transit systems. From this $150 million allocation, the Cincinnati Transit Company received low-interest loans for new buses and a few dozen bus shelters.

The event that brought significant federal funding to later phases of BART (at full build-out, BART received approximately 20 percent federal funding)

and new projects in cities nationwide was the planning and construction of the Washington, DC, Metro. The National Capital Transportation Act of 1969 shifted funding away from Washington's proposed Inner Loop Freeway, which portended widespread demolition of the capital's historic neighborhoods. Federal funding for Metro's first phase was and still is the only rapid transit project to receive funding according to the 90/10 formula that built urban interstate highways in cities across the United States. Subsequent Metro allocations, necessary to complete the full one-hundred-mile system planned in 1966, required 25 percent and 37 percent local funding.

FORMATION OF OKI, SORTA, AND THE 1971 REGIONAL RAPID TRANSIT PLAN

The Federal Aid Highway Act of 1962 mandated the formation of a local agency in each metropolitan area to administer the allocation of federal funds for local infrastructure projects. A year later the Ohio, Kentucky and Indiana Regional Council of Governments was established, and that agency—commonly known as OKI—has since overseen regional highway and public transportation planning.

In 1968 the Southwest Ohio Regional Transit Authority—better known as SORTA—was established in anticipation of the public takeover of Cincinnati Transit, the bus-only descendent of the Cincinnati Street Railway. In order to take advantage of newly available federal funding, OKI needed a dedicated local revenue source. It was originally hoped that SORTA would draw funds from all of Hamilton County, enabling countywide bus service and a local match for a federally funded rapid transit network. Unfortunately SORTA encountered a five-year delay in securing such funding, and when it did, it was sufficient only to operate a parsimonious city-based bus service.

A bright but short-lived moment in the history of public transportation in the United States arrived with the Urban Mass Transit Assistance Act of 1970, which authorized over $10 billion according to an 80/20 federal-local formula. OKI, like similar agencies nationwide, outlined an extensive rapid transit system for Cincinnati that could compete for federal funds. OKI's 1971 Regional Rapid Transit System—which resembled the scale and character of the Washington Metro—was the most ambitious officially proposed rapid transit system in city history and much larger than the various schemes of Bion Arnold's 1912 report. The $500 million system consisted of five lines totaling fifty-seven miles, including twelve miles of subway construction in

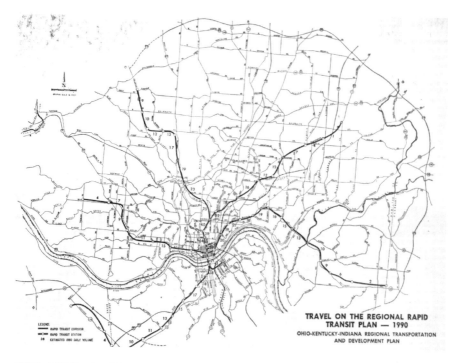

OKI's 1971 Regional Rapid Transit Plan. *Courtesy of the Ohio, Kentucky and Indiana Regional Council of Governments.*

Cincinnati, Covington and Newport and an additional twenty-four miles of elevated track throughout the region.

Cincinnati at last had a very real chance of building a high quality regional rapid transit system. The Hamilton County Democratic Party and several prominent Republicans and Charterites supported an expedient public takeover of Cincinnati Transit and construction of a regional rapid transit system, but the era's rising political star, Tom Luken, played both sides of Cincinnati Transit's takeover and asserted that Cincinnati was too small for a rail system. Like most of Luken's claims, this one was factually incorrect, as three metro areas of a similar in size to Cincinnati in 1970 were awarded huge new-start rapid transit UMTA appropriations:

(1) Atlanta, Georgia voters approved a 1.0 percent sales tax in 1971 (reduced to 0.5 percent after ten years). The city received over $800 million in grants to build MARTA, the forty-eight-mile rapid transit system that presently attracts 260,000 daily riders.

(2) Baltimore, Maryland, was awarded over $1 billion in federal funds for construction of the sixteen-mile Baltimore Metro Subway after the

Attempts to Revive Rail Transit in Cincinnati

Maryland General Assembly approved $144 million in 1976. The Baltimore Metro's single line presently attracts forty-nine thousand daily riders.

(3) Miami–Dade County, Florida voters approved a $132 million bond issue in 1972. This sum was used as the local match in a UMTA application that awarded $575 million in 1977. Construction of the twenty-two-mile elevated Metrorail system began in 1979, and it opened in phases beginning in 1984. It currently attracts sixty-seven thousand daily riders.

Luken's council terms and ascendancy to the mayor's seat in 1971 occurred at the worst possible time. Instead of working to build the kind of consensus that existed in Atlanta, Baltimore or Miami or proposing something creative such as a change in state law permitting Cincinnati Southern Railway revenues to fund local transit, Luken muddied the conversation and assailed any proposal or consensus formed by others. Luken's unrelenting antipublic transportation stance, which made constant use of rhetorical tricks and appeals to the penny-wise but pound-foolish, proved to be a political winner not just for him, but a host of later local politicians who emulated his style.

The "temporary" 0.3 percent city earnings tax approved by Cincinnati voters in 1973 under Luken's watch has haunted the region ever since. It enabled SORTA to buy the assets of Cincinnati Transit and establish Queen City Metro, but without a dollar to spare. Thirty-seven years later, the temporary earnings tax is still in effect; it hasn't been replaced or augmented by a countywide tax; and Metro has been unable to provide sufficient service to a region that has since sprawled far outside Hamilton County.

By the time Cincinnati got in the game in 1973, competition for federal dollars had grown fierce as insufficient funds were available for construction of rapid transit systems in every city. OKI did send an application to Washington in 1976, but without a local funding match, it was a futile exercise in grant writing. As a result, Cincinnatians paid in but received nothing of significance from the Urban Mass Transit Assistance Act. Cincinnati was also unable to take advantage of amendments to the 1976 Federal Aid Highway Act, which permitted the shifting of allocated funding from "non-essential" interstate highways to public transportation projects because funds were needed to fill gaps in Interstates 275 and 471.

CINCINNATI'S INCOMPLETE SUBWAY

LIGHT RAIL PROPOSALS IN THE 1970s

The exhaustion of UMTA funds, the inflation of the late 1970s, and new technology shifted new-start public transportation planning in the United States to the cheaper light rail mode. For Cincinnati, OKI drastically reduced the scale of the 1971 Regional Rapid Transit Plan and presented a light rail network that would utilize various existing railroad right of ways and the existing subway tunnel under Central Parkway.

The subway's use was studied more closely as part of the Westside Transit Study, which was completed in 1981. This study was motivated by the abandonment of 18 miles of the Chesapeake & Ohio's Western Hills line in 1979 including its Cheviot Yard, which promised to become a valuable redevelopment site on otherwise built-out Glenway Avenue. The line was abandoned for two reasons: the legs of its Mill Creek viaduct blocked the planned reconfiguration of trackwork for Chessie System's Queensgate Yard, and production at the Fernald uranium processing plant, the line's only major customer, fell 90% in the 1970's from the plant's late 1950's peak.

The westside transit plan sought to connect the C&O line and the subway via a new bridge parallel to the Western Hills Viaduct, then to extend the

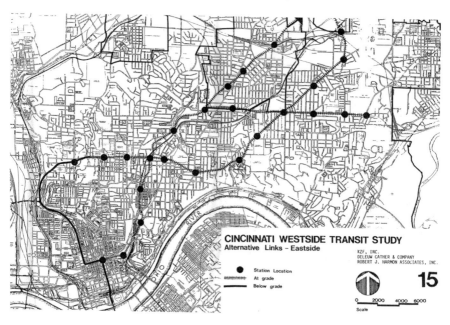

Overview of subway extension north to Martin Luther King Drive and other possible light-rail routes. *Courtesy of the Cincinnati Westside Transit Study.*

Attempts to Revive Rail Transit in Cincinnati

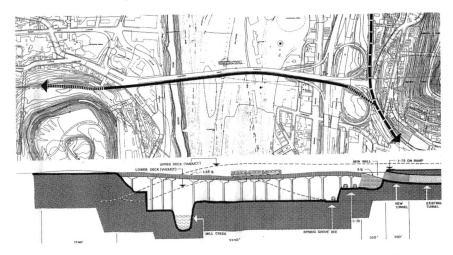

Conceptual drawing of new transit viaduct parallel to the Western Hills Viaduct. *Courtesy of the Cincinnati Westside Transit Study.*

Transit-oriented redevelopment of Cheviot Yard, now the site of the Glenway Crossings shopping center. *Courtesy of the Cincinnati Westside Transit Study.*

subway south from Central Parkway under Walnut Street. Alternatively, a "transit mall" would see light rail trains emerge from the old subway and operate on the surface of Walnut Street, similar to the arrangement in Buffalo, New York. A medium-density office and retail development was

planned for the Cheviot Yard property, which in one configuration was to be served by two stations.

But this effort was stymied by the failure of 1.0 percent countywide transit sales taxes in 1979 and 1980. These taxes would have eliminated Cincinnati's 0.3 percent property tax and replaced it with a funding source able to fund countywide bus service and attract federal dollars for a light rail network. Prominent in the effort to defeat the tax levies were the United Auto Workers, who decried buses as "Communist." Mayor Ken Blackwell, a lifelong opponent of improved public transportation, figured prominently in the 1980 antitax campaign. He opposed a permanent transit tax, stating that "A 1980 plan counting heavily on buses...may be a lot like an 1880 plan counting on horse-drawn carriages to meet 20^{th} Century needs." He further justified his position by declaring buses would be outmoded by 1995 and replaced by moving sidewalks.

In the early 1970s, it was believed that UMTA would be renewed in perpetuity as were the Federal Highway Aid acts and that all American cities would eventually have regional rail systems built by the federal government. But any near-term hopes for a return of rail transit in Cincinnati were dashed by President Ronald Reagan and his signing of the Federal-Aid Highway Act of 1981 and Surface Transportation Assistance Act of 1982. These two acts increased funding for new interstate highways and expansions and repairs to existing ones while federal funds for local rail-transit capital projects were slashed. This change of course meant cities with heavy-rail, rapid-transit systems were unable to expand; for example, MARTA was unable to extend its transit lines to follow suburban Atlanta's rapid growth into rural counties. Baltimore, which completed one heavy-rail subway line in the early 1980s with funding allocated in the 1970s, was forced to build the next line in its network as a surface light-rail line. The budget for this light-rail line was so limited that single-track sections were constructed and it was made to cross but not directly transfer with the existing subway.

The Surface Transportation Assistance Act also gutted federal subsidies for operations expenses made available in 1974, causing a budget crisis for Queen City Metro and the rest of the country's transit agencies. Metro lost $8 million per year, leaving it with only its $12 million annually from the 0.3 percent Cincinnati earnings tax to fund operations. Politicians in Cincinnati and nationwide exploited the situation—as Reagan surely knew they would—to further celebrate automobiles and vilify public transportation.

Ironically, uranium processing at Fernald increased in the 1980s just a few years after the C&O line was abandoned. But the plant's revival was

Attempts to Revive Rail Transit in Cincinnati

While serving as mayor, Ken Blackwell opposed SORTA's countywide sales tax, stating that buses would be obsolete by 1995 and replaced by moving sidewalks. *Courtesy of University of Cincinnati Archives and Rare Books.*

short-lived, as discoveries of contamination in the area's ground water led to a $72 million settlement and closure of the plant. The surviving part of the rail line, which traveled north to Hamilton, was used during the plant's $4 billion 1992–2006 cleanup to transport over 100 trainloads of radioactive waste to Utah.

Meanwhile, the relatively insignificant sum of money necessary to preserve the C&O line in Cincinnati for transit purposes was not allocated. Hamilton County Engineer Donald Schramm evoked a clause in the railroad's 1902 charter and forced it to dismantle its 28 trestles and overpasses in 1984. The Cheviot Yard, instead of becoming a transit-oriented development and a cultural hub of the West Side, became the indistinct Glenway Crossings shopping center. So many structures came to block the right of way by 2002 that it could not be included as part of the Metro Moves plan.

I-71 Light-Rail Plan in the 1990s

In the mid-1990s, OKI again studied light rail, focusing on what was known as "I-71 Light Rail." This thirty-plus-mile line, in its full build-out, was to connect Florence, Kentucky, and the Cincinnati–Northern Kentucky International Airport to the south with Blue Ash and Mason to the north. The line was planned to cross the Ohio River on a new bridge parallel to and immediately adjacent to the Clay Wade Bailey Bridge and travel through Downtown Cincinnati and Over-the-Rhine on Walnut Street and Main Street.

The basin and the University of Cincinnati would be connected by a mile-long tunnel beneath Mt. Auburn. In two variations, the tunnel would have either run directly between its portals or deflected east to serve a deep station under Auburn Avenue at Christ Hospital. North of Xavier University, the line was planned to use the CL&N tracks at least as far north as Blue Ash, then travel on its own right of way to King's Island.

Significant aspects of the 1998–2000 reconstruction of Fort Washington Way were built to accommodate this line, which illustrated the ability of OKI to coordinate projects of different modes. Specifically, the Main Street and Walnut Street overpasses were built to easily accept future surface rail, and the new Second Street was paved to accept installation of light-rail tracks without requiring a total rebuild. At the time of this writing, it appears that the Cincinnati Streetcar will be built over the Main and Walnut Street overpasses in 2011 or 2012 and take advantage of the provisions made more than a decade ago.

Attempts to Revive Rail Transit in Cincinnati

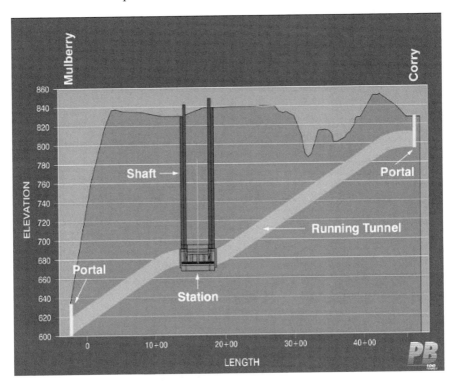

In the late 1990s, test borings were made for the proposed Mount Auburn light rail tunnel between Mulberry Street and Corry Street. *Courtesy of the author.*

A federal grant awarded late in the Fort Washington Way planning process funded construction of the Riverfront Transit Center, a bus and rail facility stretching 3,740 feet between Broadway and Central Avenue beneath Second Street; however the transit center was not a part of the I-71 light-rail plan. The center is designed for and will eventually be used by commuter or intercity trains.

METRO MOVES: COUNTYWIDE BUS AND LIGHT RAIL, 2002

In anticipation of a 2003 renewal of the Transportation Equity Act of 1998, SORTA placed a sales tax on Hamilton County's November 2002 ballot. Whereas the 1979 and 1980 campaigns sought to abolish the City of Cincinnati's 0.3 percent earnings tax and replace it with a 1.0 percent

Cincinnati's Incomplete Subway

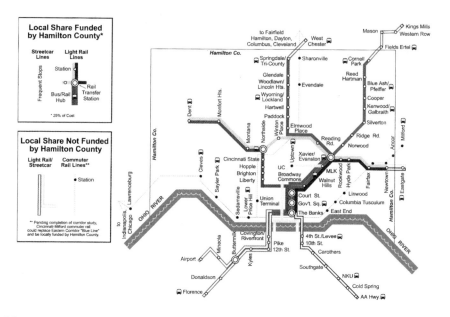

Metro Moves network map. *Courtesy of Southwest Ohio Regional Transit Authority.*

countywide sales tax, SORTA's 2002 levy retained the city earning tax and augmented the agency's revenue with a $0.005 countywide sales tax that would have generated about $60,000,000 annually. This tax would have at last funded the countywide bus service envisioned when SORTA was established in 1968.

What came to be branded as "Metro Moves" also included funding for construction and operation of an extensive electric light rail network. Five new light rail lines were to radiate from Cincinnati in all directions, including the "I-74 Line," which was to have used the old subway tunnel for its downtown approach. In a cost-savings effort, the planned Mt. Auburn Tunnel was removed from plans and replaced by a modern streetcar line between downtown Cincinnati and the University of Cincinnati.

Maps illustrating a full Metro Moves rail build-out included light rail extensions into Butler and Warren Counties, but these extensions could not be funded by the Hamilton County tax and would therefore be the responsibility of those counties. Additionally, extensions into Northern Kentucky required separate funding, a situation greatly impaired by Kentucky's state constitution, which prevents localities from levying permanent transit taxes.

Attempts to Revive Rail Transit in Cincinnati

METRO MOVES IS DEFEATED

Issue Seven, the half-cent sales tax that would have funded Metro Moves, was the victim of bad timing. The poor on-field performance of the Reds and Bengals fueled a media-stoked backlash against the half-cent stadium sales tax enacted in 1996 and created an anti-tax climate which saw the failure of a $400 million Cincinnati Public Schools bond issue on the same ballot. The era's dim civic mood was exacerbated by the high-profile failure of an effort to build a Nordstrom's department store on Race Street, the 2001 riot, and the appearance of agitators such as Chris Smitherman.

In a conversation with the author, local commercial real estate developer John Schneider, who chaired the Metro Moves campaign, stated that the

John Schneider. *Courtesy of John Schneider.*

campaign was rushed in order to create a local match for an anticipated renewal of the Transportation Equity Act in 2003. As a result, the merits of the plan were not sufficiently understood by the public, and the dialog was instead dominated by the anti-rail propaganda of national figures such as Randal O'Toole and Wendell Cox.

Meanwhile, the unethical activities of Alternatives to Light Rail Transit, aka "ALRT", were certainly responsible for part of its landslide 2–1 defeat. In fall 2002 the Metro Moves campaign sued the ALRT PAC, which was co-chaired by U.S. Representative Steve Chabot, Hamilton County Commissioner John Dowlin, and Hamilton County Auditor Dusty Rhodes, and personally sued chairman Stephan Louis for violating Ohio's law against making false statements during an election.

Specifically, the ALRT PAC and Louis were sued for broadcasting a television advertisement that contained the statement "The Federal Transit Administration rates it [Metro Moves] one of the worst plans in the country." The FTA made no such statement, and on July 16, 2003, the Ohio Elections Commission found ALRT and Stephan Louis in violation of Ohio Revised code section 3517.22(B)(1). Despite this unethical activity and his lack of professional credentials, the anti-rail Louis was appointed to SORTA's board in 2003. In 2009, while still serving on the board, he campaigned for Issue 9, the anti-rail charter amendment.

Between 2000 and 2010, John Schneider led over four hundred Cincinnatians on trips to Portland, Oregon, to study the city's light rail and streetcar systems. *Courtesy of John Schneider.*

Attempts to Revive Rail Transit in Cincinnati

Modern Streetcar and Issue Nine

In 2007, part of the modern streetcar line planned as part of Metro Moves was revived as a stand-alone project. An initial proposal for a short streetcar line between the riverfront and Over-the-Rhine's Brewery District was expanded in 2008 to include a route up the Vine Street hill to the University of Cincinnati. Unlike any previous attempt to bring rail transit back to the Cincinnati area, this line would be built and operated by the City of Cincinnati without a new tax or funding from the county.

The plan was initiated by city councilmen Chris Bortz, Charterite, who soon after won the support of Mayor Mark Mallory, a Democrat. In 2008, the plan was supported by fellow Charterite Roxanne Qualls, Democrats David Crowley, Cecil Thomas, Laketa Cole and Jeff Berding and Republican Leslie Ghiz. The plan was consistently opposed by John Cranley, a Democrat, and Chris Monzel, a Republican.

In fall 2008, observers were alarmed by the announcement of a new coalition formed between libertarian PAC Citizens Opposed to Additional Spending and Taxes (aka COAST) and the local chapter of the NAACP led by former city councilman and Charterite Chris Smitherman. In December, COAST/NAACP announced a petition drive to place an antipassenger rail charter amendment on the November 2009 ballot. What ensued was a disgusting abuse of the charter amendment process, a dirty and unethical campaign led by COAST and the NAACP and an inexplicably poor effort by local media to accurately report the implications of what came to be designated Issue Nine.

The language of the charter amendment, authored by COAST attorney Chris Finney, read:

> *Shall the Charter of the City of Cincinnati be amended to prohibit the city, and its various boards and commissions, from spending any monies for right-of-way acquisition or construction of improvements for passenger rail transportation (e.g., a trolley or streetcar) within the city limits without first submitting the question of approval of such expenditure to a vote of the electorate of the city and receiving a majority affirmative vote for the same by enacting new Article XIV?*

Defeat of Issue Nine took on a greater urgency after Ohio was considered a frontrunner for a $400 million federal grant for intercity rail passenger service among Cincinnati, Columbus and Cleveland. Area attorneys notified

Chris Smitherman speaks in support of Issue Nine, the antirail charter amendment, at Ollie's Trolley in May 2009. *Courtesy of the author.*

Attempts to Revive Rail Transit in Cincinnati

Former Cincinnati mayor and lifelong rail transit opponent Tom Luken speaks in support of Issue Nine outside City Hall in November 2009. *Courtesy of Travis Estell.*

local media outlets that Issue Nine concerned not just the planned streetcar, but the ability of 3Cs' trains to enter Cincinnati's city limits. For several frustrating months, the local media covered COAST/NAACP's publicity events while refusing to discuss the full implications of Issue Nine.

At one such media event held at Ollie's Trolley on Liberty Street, Tom Luken made a reentry into local political affairs after having recently left SORTA's board, where he was appointed by his son Charlie and for several years served alongside anti-transit cohort Stephan Louis. Luken was a natural fit for the COAST/NAACP coalition, whose members were observed collecting signatures from residents of nursing homes and intoxicated bar patrons, and who mischaracterized the charter amendment during public appearances. During the summer, COAST/NAACP combined Issue Nine with another charter amendment campaign preventing sale of the Cincinnati Waterwoks. In promotion of what came to be designated Issue Eight, Chris Smitherman, on his weekly *Smitherman on the Mic* radio show, suggested that a privatized waterworks might send syphilitic water to black neighborhoods and insinuated that the proposed streetcar project was backed by the same shadowy figures.

Chris Finney, author of Issue Nine, stated before city council that "any means any," admitting that his antirail charter amendment would affect all passenger rail within Cincinnati city limits, including the Cincinnati Zoo's tourist train. *Courtesy of Nick Sweeney.*

Aside from making stump speeches and mentoring Smitherman, Luken played a role in a coordinated media blitz that branded various aspects of the Issue Nine campaign as COAST, NAACP or "Tom Luken" stories. This three-pronged attack succeeded in saturating the public with Issue Nine propaganda several times a week, well ahead of the appearance of organized opposition. Such opposition appeared in May with the formation of Cincinnatians for Progress, a nonpartisan PAC chaired by Bobby Maly, Rob Richardson and Joe Sprengard.

A blow-by-blow account of the Issue Nine campaign could fill half of this book. Suffice to say that its defeat, along with the resignation of John Cranley from city council in early 2009 and his replacement by Greg Harris, and then Laure Quinlivan, made possible the political environment that enabled the Cincinnati Streetcar plan to win a $25 million Urban Circulator Grant in July 2010. Cincinnati's four-year streetcar effort survived the turnover of elected officials, a hostile local media and the best efforts of the city's most notorious anticity agitators.

Attempts to Revive Rail Transit in Cincinnati

Bobby Maley, left, Rob Richardson, center, and Joe Sprengard, officers of Cincinnatians for Progress, celebrate the defeat of Issue Nine at Arnold's Bar on November 3, 2009. *Courtesy of the author.*

The plan's unlikely victory showed a young generation that the success or failure of enormously significant issues often hinges on the actions of one or two individuals. Such individuals were not present in the late 1920s, when the subway project was killed, or in its numerous attempted revivals. At the time of this writing, the streetcar project has not broken ground, but its construction appears to be assured. Its success will undoubtedly help the case for a regional rail-transit system that could utilize the old subway.

CHAPTER 14

THE FUTURE

Contrary to commonly heard sentiments, the subway is in excellent physical health and can accommodate the types of modern trains that operate on the country's newest light rail systems such as those in Charlotte and Seattle. The subway has been maintained continuously since it was built and the $3 million Rapid Transit Tubes Joint Reconstruction Project undertaken in early 2010 ensured its viability for generations to come. Its assessed value can be used as a local match for a federal award that could cover much of the estimated $115 million cost of rehabilitating the tunnel, rebuilding its stations, and installing track and electrical systems.

Structural Issues

Two minor issues must be resolved if the subway is ever to be used for its intended purpose. The 1950s-era water main must be removed, which according to some reports is planned by 2020 due to reconfiguration of the overall water system. Second, the wooden runners in the outbound tube must be removed, as they were when the water main was installed in the inbound tube.

The major issue confronting the subway's use is the character of its existing stations. A 2008 report by the URS Corporation recommended reconstruction of the existing stations in order to serve modern low platform light rail trains. Reconstruction will also ease the installation of elevators to permit easy platform access for those in wheelchairs.

Present-day view of Walnut Street, looking north from the skywalk. As has been the case since the 1920s, use of the Central Parkway subway will require either a subway extension beneath Walnut Street or the operation of trains on the surface. *Courtesy of the author.*

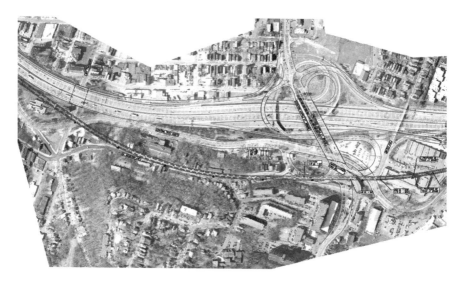

Proposed subway extension under McMicken Street. *Courtesy of the Ohio Department of Transportation.*

The Future

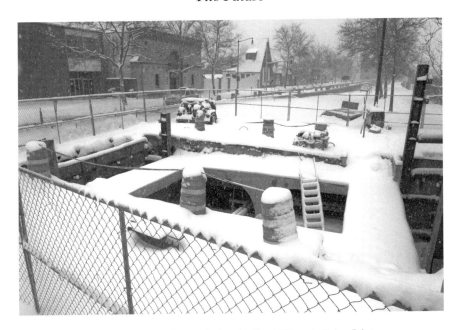

View of the subway near Ravine Street during the Rapid Transit Tubes Joint Reconstruction Project in early 2010. *Courtesy of the author.*

Extension of the subway south under Walnut Street will be complicated by the planned construction of streetcar tracks in 2011 or 2012. Walnut Street remains preferable to Vine Street due to its proximity to the Government Square bus terminal, and a Vine Street tunnel cannot turn east beneath Fifth Street due to the Fountain Square parking garage, which was built beneath the street and abuts the foundation of the Westin Hotel.

Alternately, construction of a tunnel beneath the Ohio River will require a Walnut Street subway to be dug by a tunnel boring machine and begin its descent immediately south of Central Parkway. This method of construction would avoid most disruption to Walnut Street and also across the river in Covington. Such a tunnel would enable TANK to turn its Kenton and Boone County buses at the Covington Transit Center, enabling tremendous fuel and time savings.

SUBWAY VERSUS STREETCAR

Streetcars are poised to return to Cincinnati's streets by 2013, and there have been some calls for them to operate in the subway tunnel. There is no technical reason why they cannot do so, but such a scenario is not a part of any immediate plan. In Portland, Oregon, there are plans for light-rail trains and modern streetcars to operate on shared trackage on a new bridge. Such mixed usage is a future possibility for the subway tunnel.

THE SUBWAY AS PART OF A REGIONAL TRANSIT SYSTEM

As compared to most American cities, Cincinnati has an extraordinarily complicated street layout. There is no single dominant street, such as High Street in Columbus or Euclid Avenue in Cleveland, which are the obvious starting points for any subway conversation in those cities. This presents a serious problem for Cincinnati, since funding will never be available for construction of subway lines under every radial avenue, meaning the public

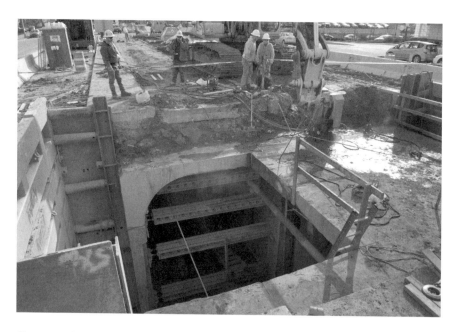

Crews saw through the roof of the subway at Liberty Street in early 2010. *Courtesy of the author.*

The Future

must be convinced that certain areas of the city should be served by rail transit before their neighborhood and workplace.

A regional network that converged on the neighborhoods collectively known as "Uptown" was the strategy behind the configuration of the 2002 Metro Moves network. This area, home to the University of Cincinnati and a half dozen hospital complexes, is the region's second-largest employment center and is not well-served by expressways. Uptown offers the best cost-benefit for tunnel construction and despite its high cost should be the first priority of any regional rail transit network.

The Rapid Transit Loop, including the existing subway, was not designed to serve this area because in the 1910s the University of Cincinnati was a small municipal college and the hospitals were a fraction of their current size. 1970s light rail plans sought to serve the area with a bored extension of the existing subway, and such a scenario could be part of a new regional system. Alternately, the existing subway could be put to use serving lines from Western Hills, College Hill, Interstate 74, or Interstate 75.

Provisions for a light rail right of way have been incorporated into plans for Interstate 75's upcoming reconstruction. However, as plans for its routing in Camp Washington and near Ludlow Avenue have not been finalized, we do not know what character it will assume. At least one subway extension has been drawn under McMicken Street.

Future Campaigns

With the present 0.3 percent city earnings tax, the Cincinnati area cannot hope to win large federal new-start grants for a regional rail network that might utilize the subway. A countywide tax increase will be necessary both to compete for federal money and to operate a system once in place.

The success of any future campaign is contingent upon getting the message out—something that has been inhibited in the past by a local media that was at best indifferent. The defeat of Issue 9 in 2009 can be attributed in large part to the maturity of the Internet as a force in local politics. During the 2002 Metro Moves campaign, online activities were limited to basic websites and group email lists. By 2009, the growth of the Web's usage by all age groups, along with the appearance of blogs and social media, allowed the No on Nine campaign to instantly fact-check COAST/NAACP.

Within a few years, Internet social networks will grow ubiquitous and ordinary citizens will be directed immediately to fact-checking websites. The

type of people who have played the politics of decline in Cincinnati for so long will not survive this new reality. This new era in communication portends a new era in transportation in Cincinnati—one in which citizens will review online materials at their own pace, will familiarize themselves with facts free from outside interference, and armed with the truth about our subway, will one day cast votes in favor of putting it into operation.

Appendix A

CANAL STATEMENT

STATEMENT DELIVERED BY GEORGE BALCH AND PRINTED IN THE CINCINNATI ENQUIRER *ON JANUARY 19, 1913*

Mayor Hunt's statement, given out on Friday, indicates that he is now set on building the proposed canal subway and boulevard only as far as Liberty Street and have the rest of the property covering a distance of five miles, used simply as an open ditch for street railways with a parkway on either side where the width of the strip will permit," declared George R. Balch, President of the Association for the Improvement of the Canal, yesterday.

"If the Mayor's original suggestion of having the boulevard and subway run only as far as Liberty street, and then devote the subsequent five miles of the city's leasehold to an open ditch, flanked on either side by roadways, were carried out, several of the principal features of the campaign made for the elimination of the canal would be defeated, not the least of which was the establishing of a continuous park system that should prove a healthgiving medium to the people of that congested section along the canal as far as Cumminsville and the elimination of bridges that are proving such a hinderage to traffic.

"I believe that Mayor Hunt's suggestion that the subway need not be carried all the way to Mitchell Avenue is entirely correct. However, to serve its purpose in the elimination of traffic crossings, the proper establishing of a boulevard an in the matter of keeping faith with the citizens, who so loyally supported the subway and boulevard improvement, the subway should be carried to Ludlow Avenue in Cumminsville."

Appendix A

Build a Parkway

"Beyond that point the city easily could aquire sufficient ground on either side of the canal to build an adequate parkway. The city owns the Bowler Estate property beyond Ludlow Avenue. Louis Reakirt and other have offered to donate strips of land further along and I am certain that the Bethesda Hospital, which also has property abutting the canal at this point, would contribute land to a boulevard, thus assuring a strip sufficiently wide from Ludlow Avenue to the basins near Clifton Avenue, and from there to Mitchell Avenue is but a short distance.

"That the open ditch and parkway idea from Liberty Street, or even from Mohawk bridge, or from Brighton, is not feasible and certainly not creditable to the city from an improvement point of view, is clear to anyone acquainted with this territory. In the vicinity of Mohawk and Brighton, the canal is practically hemmed in by residences and business houses, which come right down to the banks of the waterway. If tow tracks were laid in an open ditch along this section there would be little left on either side for a parkway, a fact which in itself defeat the boulevard idea and made the parkway more or less of a joke.

"Condemning property on either side of this narrow strip would not result in a satisfactory solution to the problem. The nearest point, to my way of thinking, at which there should be a reasonably satisfactory dividing of the boulevard and the placing of tracks outside a covered subway would be at Dixmyth Avenue, a point about three miles from the downtown end of the canal, while the logical and most satifacotry entrance to the covered subway would be at the point I first mentioned, namely, Ludlow Avenue in Cumminsville."

Make Certain Promises

"When we went before the people of Cincinnati for support on this proposition to acquire the canal for the city, we made certain promises in order to secure support. These promises included relief from existing conditions for the people living in the congested districts between the downtown terminals and the canal and the residential sections of Brighton, Camp Washington, Cumminsville and the intermediate territory, and building of a covered subway which would ensure rapid transit to the heart of the city, and the building of a wide boulevard that should be a continuous

park for the residents on either side of the canal and a thing of beauty and pride for the people of Cincinnati.

"To curtail the original plans to as great extent as has been suggested would be breaking faith with our citizens, would materially decrease the benefts to be derived from the leasehold which the city has secured on the canal property, would show a lack of progress not in accord with the general trend of the times, and I believe would be in violation of the provisions of the act empowering the city to lease the canal property, as the Johnson bill provides specifically for a 'covered subway', and as open ditch can hardly be so described."

Street Railway Purposes

"After this bill was prepared there was a very large meeting of civic organizations of Cincinnati at the Sinton Hotel. The bill was read and discussed, section by section. The part of the bill that provoked the most discussion was the part touching the use of the boulevard for street railway purposes. That excited more interest than any other part. The discussion resulted in several changes in the draft of that part of the bill. The sentiment was unanimous that the surface of the street should be free from occupancy by any kind of railway, steam or electric. At the same time it was recognized that the use of the canal bed for interurbans would remove much of the difficulty surrounding the subject. To provide for such use the exception in favor of a subway was introduced. The common understanding of a subway, which you speak of a subway for street railway or electric purposes, is a way beneath the surface of the street, and not a mere sunken roadway, open at the top. A suggestion at that meeting that the proposed boulevard be divided into two slits by an electric street or steam railway sunken a few feet or more beneath the level of the surface would not have been accepted.

"It seems certain to me that the operation of a street or electric railway in an open trench would be a violation of the legislative act and would forfeit the canal to the state. We have a warning in the fate of Eggleston Avenue. In 1863 the Ohio Legislature passed an act granting the canal bed between Broadway and the river to the city of Cincinnati for highway purposes."

Appendix A

Forfeiture to State

"Afterwards the Little Miami Railway, by consent of the city, constructed a steam railroad track on that part of Eggleston avenue that had formerly been the canal bed. The result was that the Supreme Court of Ohio decided that so much of Eggleston Avenue as was within the limits of the old canal was therefore forfeited to the state of Ohio by reason of violation of the terms of the grant in allowing the railroad company to use the ground for railroad purposes, even though the city of Cincinnati had spent nearly a million dollars in filling and paving the entire avenue, with our filling and paving, belons to the stat of Ohio which rents it to the Pennsylvania Railroad.

"The Association for the Improvement of the Canal in conducting its successful campaign for canal elimination—a campaign that had failed many times during the previous thirty years—had in mind the beautifying of the city, the increase in health condition, the building up of a greater commerce and the general welfare and growth of the city, and felt that this could be accomplished by the building of a beautiful boulevard, with a subway underneath. We still feel that this is the use to which the canal property should be subjected, and our committee is prepared to meet the Mayor on any adjustment of his plans that will bring about the result that was aimed at when the campaign for canal elimination was begun."

Appendix B

RAPID TRANSIT LOOP ARTICLE

"'Watch Your Step! All Aboard!' And Away We Go Around Greater Cincinnati's New $6,000,000 Rapid Transit Loop."

By Rudolph Benson

Originally printed in the April 18, 1917 Cincinnati Times-Star

Reprinted with permission of the E.W. Scripps Company

Cincinnatus breathed a sigh of relief Wednesday. The rapid transit loop is to be a reality. Cincinnati's transportation system is to be revolutionized. The electorate sealed the verdict with their votes Tuesday. Preparations were under way Wednesday for calling a meeting of the Rapid Transit commission that it might grant the proper authority to the engineering forces to proceed with the plans. These plans, Chief Engineer Frank Krug announced Wednesday, will require about ten months to mature. In this time the engineers must lay their definite lines, must determine the nature of the geological formations through which the line is to operate, prepare specification for contractors who bid on the work, and do the thousand and one other bit of work incident to the building of a system that will cost many millions, and because of Cincinnati's peculiar topography, involves almost every known phase of railway engineering, from subway and tunnel building

Appendix B

to bridge and trestle construction. It is planned to build the loop in sections. Once the contracts are ready for letting, several sections will be started at the same time. It is believed that the most difficult part of the world will be that of building a subway under Walnut Street, from the canal to a point between Third and Fourth streets. This will involve the strengthening of the foundations of buildings along the street, moving sewer, water, and gas mains and telephone and telegraph conduits. Engineer Krug plans to have this section of work started with the first contracts. It will require four years, he estimates, to build the entire loop.

No bonds are to be issued until the plans are all ready, and then only as the money is needed from time to time. This will keep at a minimum the sinking fund and interest charges, and relieve both the taxpayers and the Cincinnati Traction company of unnecessary burdens. Definite policies of construction and financing, however, will not be worked out until the Rapid Transit commission and the Street Railway committee of Council hold meetings.
In the meantime, to get an idea of what the loop is and what it will mean, let us project ourselves into the future on the basis of the present plans see what an inspection trip over the system five years hence will be like. So "All aboard! Watch you step! Lively, now, lively!"

Into the Subway then Whizz Away

We meet City Engineer Frank Krug at the Fountain Square station by appointment, and he leads us down into the subway to embark on our inspection trip. The Fountain Square station is under Walnut street. The main stations is on the canal between Elm and Vine streets, but the Fountian Square station is a commodious palce, designed to accommodate the transient local traffic. It is built of heavy reinforced concrete, with tile facing, and reminds us vividly of the New York and Boston subway stations. An electric train of four cars whizzes up in the station and stops long enough to take us aboard. We have no trouble getting on, for there are three doors in the side of each car, opened by guards, and the floors of the cars are on a level with the station platform.

Forty-Five Miles an Hour

Settled in comfortable seats and bounding along under Walnut street at a speed that we are informed can be maintained to the rate of 45 miles per hour, we have a few moments in which to observe the car we are in. It is

of metal construction throughout, with a concrete floor, 70 feet in length and 10 feet in width. The cars are designed accommodate 250 passengers each, Mr. Krug informs us, so that the four-car train can carry a thousand persons—quite a boon during rush hours. In the duller hours, Mr. Krug says, it will not be necessary to run as many cars to the train. The motive power, we are informed, is by means of a third rail.

We have barely had a chance to make these observations when we arrive at the Ninth Street station. Here scores of workers of a big industrial and commercial center get on in less time than it takes to tell and the train is on its way. We are soon out of the Walnut street subway—the most expensive construction of the entire loop, built at the rate of more than $1,000,000 a mile and are drawn up at the Canal station, the main station, in a jiffy.

At Main Station

This station is built on an elaborate scale. It was made the main depot because it was determined that this should be the terminus of all the interurban lines using the loop. There are tracks a-plenty here, and switches, to facilitate rapid movement and the avoidance of unnecessary confusion. The downtown stations are primarily for the local traffic. Similarly, this main station is principally for the interurban passenger and is used by the local trains largely for the transfer of interurban traffic.

Our train moves on. We are in the Canal subway. We shall remain in a subway until we reach Brighton. There are ventilating openings in the roof of the subway as far as the Liberty Street station.

At Twelfth street we find that the subway branches off, by means of numerous switches, into a freight terminal. Passenger trains do not stop here but that our inspection trip may be complete, Mr. Krug makes an exception in our case. We find that the old hospital site has been utilized as a loading and receiving station for freight. To this point the thousands of farmers of the Middle West are shipping the produce of their farms and dairies by interurban and in turn there is being shipped them from this point the products of Cincinnati manufacturers and the wares of her merchants. We find that the walls of this subway freight station have been built strong enough to form the foundations of a municipals convention hall for the men who planned and built it had vision enough to assume that a convention hall someday will be built. And in conjunction therewith, we find that Mr. Krug has an ambitious plan that may some day be realized. He would have

Appendix B

the rapid transit commissioners acquire the property for two blocks north of the hospital site, bounded by Canal street, Ann street, Central avenue and Fifteenth street, to be converted into an immense municipal market. The commissioners favor it, too, we find, but there is the old stumbling block that obstructs municipal progress—lack of finances. And yet, say municipal market advocates, Mr. Krug among them, the economic saving that would result to the community from having such an institution located on the rapid transit line would more than pay for any expenditures that would be involved.

Out of Subway

Resuming our rapid transit trip, we are in a few minutes past the Liberty Street station on our way northward. At the Brighton station we emerge from the subway, the canal bed being utilized from here on as an open ditch. This is the point where Cincinnati's newest interurban line enters the loop. It is the Indianapolis & Cincinnati Traction company, know as "the Henry line." Which comes in direct from Indianapolis. Its construction from Rushville, its former terminus, was assured when the Cincinnati voters authorized the building of the loop. It cost millions to build the line to Cincinnati, but Charles L. Henry, "the father of interurbans," president of the road thought it well worthwhile. Traveling northwardly from Brighton station, we observe large territory as yet undeveloped. Here are large fields of verdant land, waiting to be subdivided and converted into homes and gardens for workingmen. This becomes more and more the case as we swing around the semi-circle that is formed by that section of the loop after leaving Brighton station. There are some stretches that it strikes us are ideal locations for factory colonies. They are within easy reach of railroad switching points and now thanks to the loop they are within easy reach of labor.

Trolleys Meet Loop

We also observe that the stations on the loop have been located to tap the main junction points of street car line so that transfers to and from the loop are made with the minimum of inconvenience. This is obviously true of the Fountain Square station. It is true of the Brighton station, where six or eight car lines, the Crosstown among them, practically meet the loop trains.

Speeding along through the open subway we soon pass the Hopple station at Hopple street, the Ludlow station at the south end of the

Ludlow Avenue viaduct, where many of the northwestern suburban car lines form a junction, among them the College Hill, Colerain avenue and Clark street and stop at Crawford station which is located opposite Spring Grove cemetery to take on interurban passengers brought in by the Ohio Electric railway. We have been traveling close to the Millcreek for some distance, and our olfactory senses remind us that the construction of the big Millcreek intercepting sewer has run parallel with the building of the loop, and the creek has been converted from an open sewer into a sweet smelling freshwater stream.

The guard gives the signal and our train speeds along the canal bed to Carthage pike in St. Bernard, leaving the ditch only to come to a level at Mitchell avenue, where another station will some day be built. We have remained almost entirely in the canal since leaving Walnut street, the only exceptions having been at Marshall avenue, Bates avenue and the bend south of Ludlow avenue where it was necessary to avoid curves in the canal so sharp as to make it impossible to operate at high speed.

Now on the Surface

At Carthage pike our trip through the Canal subway ends. Our line now becomes a rapid transit surface railway forming the northern segment of the loop. We pass at a fast clip over Tennessee avenue, Maple avenue and Smith road, going through St. Bernard, Bond Hill and Norwood and stopping at the Oakley station, at Smith and Duck Creek roads, to exchange business with the Cincinnati & Columbus Traction Co., which enters the loop at this point. There have been stops at various points on this rapid transit surface system between Crawford and Oakley, but no formal stations. Ultimately, when this territory, as yet undeveloped, grows to the proportions expected of it, Mr. Krug informs us, the rapid transit commissioners propose to widen the loop to a more northerly point, and place the line on an elevated structure, with half a dozen more stations along it. However, that is a matter for the future, with which we are not as yet ready to concern ourselves.

Back Toward City

We now are starting in a southwesterly direction towards the hearty of the city, passing the Dana station at Dana avenue and Duck Creek road and passing on to the Madison station at Owl's Nest Park, where the Madison

road, Madisonville and Oakley car lines transfer passenger to our train. Between the Oakley and Madison stations we have traveled in an open cut running parallel to Duck Creek road over a private right of way to Lake Avenue ravine, and in this ravine to Owl's Nest Park. We now enter a tunnel, passing under the Beechwood subdivision.

It is a real tunnel, too, right through a hill, and Mr. Krug informs us that many feet over our heads are the homes of Judge Howard Hollister, Judge Rufus B. Smith, Rudolph Wurlitzer and a number of well-known Cincinnatians.

We emerge from the tunnel onto a concrete trestle on the hillside above Columbia avenue, about 1,000 feet north of Humboldt avenue. This trestle carries us along the Ohio river bluff to the Eden Park reservoir, where it passes onto a steel elevated structure, which follows Third street, Martin street and Pearl street, and turns into Walnut.

On Pearl street, at the Pennsylvania railroad station, we stop at the Butler station for a few minutes to exchange passengers with the railroad and then go on. On Walnut street, between Third and Fourth streets, the elevated passes into the Walnut street subway, a transition quite favored by the grade of Walnut street on its descent ot the bottoms. It is quite probable that the day is not far distant when a sub-station may be established at the point where the elevated and subway meet for here is the site of the magnificent Dixie Terminal building. In a few seconds we disembark from our inspection trip at the Fountain Square station. Consulting our notes and watches we find that we have made the round trip of 16.14 miles in 54 minutes and 10 seconds, this including stops of 30 seconds each at all stations.

Many Safeguards

On our trip we have observed that every possible precaution has been taken to make the system as safe as human ingenuity can make it. There is a complete block system, providing for the automatic spacing of cars; ventilating fans, in addition to the ventilating openings, in the subway midway between stations; emergency exits in case of fire or in the event of blockades in the subway; the separation of the lighting and power ducts, so that in trouble power ducts will leave the underground system well lighted, and there are refuge niches here, there and everywhere for the safety of track inspectors.

Summing it all up, we who make this inspection trip with our engineer in the year 1922, or thereabouts, find that we are living in a new Cincinnati—a

metropolitan Cincinnati, tapping a population of millions of people within a radius of an hour and a half from Fountain square. We find that the unsightly canal has been eliminated; that congestion in the business section has been relieved; that the tenement house problem is rapidly disappearing by the building of cheap workingmen's homes in the Millcreek and Duck creek valleys, where rapid transit bring them within easy reach of their places of employment, that every branch of Cincinnati industry and commerce has benefited.

APPENDIX C

TIMELINE

1911	Ohio leases the Miami-Erie Canal to Cincinnati.
1912	The Arnold Report is published – a rapid transit beltway is studied for the first time.
1914	The Edwards-Baldwin Report is published – plans for the Rapid Transit Loop are revised.
1915	The Bauer Act permits formation of the Rapid Transit Commission
1916	In April, Cincinnatians approve a $6 million bond issue for construction of the Rapid Transit Loop.
1917	In early April, the United States enters World War 1. Two weeks later, Cincinnatians approve Ordinance 96-1917, which named the Cincinnati Street Railway as lessee of the Rapid Transit Loop.
1918	The Ohio Supreme Court declares Ordinance 96-1917 illegal. The Cincinnati Street Railway is no longer a lessee of the Rapid Transit Loop.
1919	After the conclusion of the war, final drawings for the Rapid Transit Loop are made. War-related inflation causes plans to be drastically downsized.
1920	Subway construction begins.
1921	Central Parkway bond issue fails.
1923	Another Central Parkway bond issue fails.

Appendix C

1924	Murray Seasongood begins effort to overthrow the Republican Machine. Central Parkway bond issue passes on third attempt.
1925	Murray Seasongood and five other Charterites are elected to new nine-member council. Central Parkway survey and design work takes entire year.
1926	Murray Seasongood fires all machine Republicans in city government; picks fight with Rapid Transit Commission. Work commences on Central Parkway.
1927	$6,000,000 bond issue approved in 1916 is exhausted. Rapid Transit Loop construction halts in Norwood.
1928	Central Parkway is dedicated.
1929	Rapid Transit Commission is abolished. Ohio announces plans for cross-state turnpike following canal route.
1930	Murray Seasongood leaves office and all subway talks cease as nation sinks into the Great Depression.
1936	W.P.A. funds streetcar ridership survey and preliminary design work for streetcar subway.
1939	Ohio requires 65 percent supermajority for large municipal bond issues. Subway studied and preliminary plans are made but no bond issue is placed before voters.
1941	Work begins on cross-state turnpike on the canal in Evendale.
1942	Plans for freight subway announced. Subway bonds are refinanced at low interest rate.
1946	Lease of subway for freight purposes approved by Cincinnati voters.
1951	Streetcars are removed from Cincinnati's streets. The Cincinnati Street Railway is renamed the Cincinnati Transit Company.
1955	Construction of Millcreek Expressway begins. Clifton Avenue and Ludlow Avenue rapid transit stations are demolished.
1957	Water main installed in subway.
1962	Marshall Avenue rapid transit station demolished.
1963	Liberty Street subway station converted into bomb shelter.
1966	Subway bonds are retired.
1968	SORTA established in anticipation of the public takeover of the Cincinnati Transit Company.
1971	Section Avenue subway tunnel filled.

Timeline

1973	3 percent city earnings tax approved; SORTA buys assets of the Cincinnati Transit Company and establishes Queen City Metro.
1979	Countywide 1-cent transit sales tax fails at the polls.
1980	A countywide 1-cent transit sales tax identical to the 1979 plan fails at the polls.
2002	Metro Moves, a half-cent sales tax that would have funded countywide bus service, a modern streetcar line, and five electric light rails including one that would have activated the old subway, fails at the polls.
2004	Harris Avenue tunnel in Norwood filled.
2008	URS Company completes subway report.
2009	Issue Nine, an anti-rail charter amendment aimed at stopping the proposed Cincinnati streetcar, is defeated.
2010	Rapid Transit Joint Reconstruction Project repairs the subway's deteriorating concrete.

Appendix D

FREQUENTLY ASKED QUESTIONS

Where is the subway?

The subway was built in place of the Miami-Erie Canal and covered by Central Parkway. It stretches two miles south from the portals visible from I-75 to the intersection of Central Parkway and Walnut Street. A partially completed wye turnaround extends east from this point almost to Main Street, and another wye was built beneath private right-of-way between Plum Street and Elm Street south of Central Parkway.

The subway was planned to continue south beneath Walnut Street with stations between Eighth and Ninth Streets and another between Fourth and Fifth Streets. The line was to emerge from the Walnut Street tunnel between Third Street and Fourth Street, then continue on a steel viaduct above Pearl Street east to Mount Adams.

When was the subway built?

The tunnel beneath Central Parkway was built in five phases between 1920 and 1926. The four sections between downtown and Brighton were built between 1920 and 1923. The fifth section, a 1,000 extension north of the Brighton station to the portals visible from I-75, was built in 1926.

Three more short tunnels were built in 1926 at Hopple Street in Camp Washington, under Section Avenue in Bond Hill, and under Harris Avenue

Appendix D

in Norwood. The Section Avenue and Harris Avenue tunnels were built with Rapid Transit funds while the Hopple Street tunnel was built as part of the Central Parkway project with parkway funds.

Were Stations Built?

Yes, three subway stations were built and remain intact today. Stations at Brighton and Liberty Street are simple side platform designs. The Race Street Station is an island platform, but much larger than the other two since it was to serve as the interurban terminal. Provisions for a fourth subway station were built and can still be seen at Mohawk.

Surface stations were built at Marshall Avenue, Ludlow Avenue, and Clifton Avenue but were demolished in the late 1950s and early 1960s to make way for Interstate 75. No stations were built east of Clifton Avenue because the Rapid Transit Commission prioritized its limited funds in securing a right-of-way east to Madison Road in Oakley.

How Much of the Line's Surface Route Was Completed?

After emerging from the Central Parkway tunnel north of today's Western Hills Viaduct, the line was graded for approximately 7.5 miles to Norwood's Waterworks Park. This included seven overpasses over streets, several more pedestrian overpasses, and four underpasses. A stretch of 1,000 feet was not completed in St. Bernard, nor was the final mile of the line east of Norwood Waterworks Park.

Why Were No Tracks Laid?

The financing plan for the Rapid Transit Loop was to place some capital costs on its lessee, the Cincinnati Street Railway. The city planned to build the tunnels, overpasses, and roadbed, but the streetcar company would lay the track, install the electrical systems, and purchase the rolling stock. Because Ordinance 96-1917 was declared null and void by The Ohio Supreme Court, the Cincinnati Street Railway was relieved of its contractual

obligations. The company did, however, lay a very small amount of track in anticipation of The Rapid Transit Loop's standard gauge subway trains at its Winton Road streetcar service barn.

What types of trains were to use the subway?

The subway was designed for standard gauge rapid transit trains, interurban cars, and standard freight trains.

The interurban terminal beneath Race Street anticipated interurban cars of 75 feet in length and so its 150 foot platforms made provision for two-car interurban trains. The specifics of the station's layout, however, meant the pillars of the platform area directly beneath Race Street would block the doors of rapid transit trains of more than 150 feet in length (three or four-car trains). Provisions for additional tracks can still be seen at either end of the Race Street station, where additional platforms dedicated to rapid transit trains could be built, after which time the entire island platform, with its six loading areas, could be turned over exclusively to the interurbans.

The subway was also designed for use by the era's freight trains. Turnout stubs for an 11-track freight terminal beneath the City Hospital property were built and can still be seen today. The hauling of freight in the freight terminal and the remainder of the subway was to have been performed by electric interurbans or dedicated electric-powered switchers. The operation of steam locomotives in the subway was prevented by the terms of the canal lease, however the tunnel's many ventilation shafts were built as a provision for possible future use by steam locomotives, especially if the tunnel was extended east to connect with the CL&N yard.

Were any subway trains ordered and/or delivered?

No. The purchase of the rapid transit trains themselves was the responsibility of the Cincinnati Street Railway, but they were relieved of that duty in 1918 when The Ohio Supreme Court ruled against Ordinance 96-1917. The Cincinnati Street Railway did purchase several streetcars in the early 1920s that could be easily modified and operated as coupled trains in the subway.

Appendix D

The Cincinnati & Lake Erie purchased a number of duel high platform/low platform cars in the late 1920s in anticipation of their use in the subway. The company's engineers experimented with a pneumatic device that with the push of a button covered the car's interior staircase with a panel for use in the subway's high platform stations.

In 1942 a proponent of the subway's use for freight purposes purchased a used gasoline locomotive as part of a publicity stunt. The small locomotive probably could have operated in the subway without installation of mechanized ventilation. City crews periodically drive pickup trucks through the subway without ill effect.

Did any interurbans enter into contracts to use The Rapid Transit Loop?

No. The City Engineer did hold several meetings with the leadership of the various interurban railroads in 1916 and 1917, and a few dozen surviving correspondences indicate legitimate interest on the part of the interurbans to connect to the loop. In the records of the City Engineer, these correspondences dwindled in number and then ceased around 1923. Discussion did resume with the Cincinnati & Lake Erie in the late 1920s, but details are scarce.

How were the electrical systems of the three-rail rapid transit trains and the trolley wires of the interurbans to interact?

Most conversation surrounding interurban compatibility surrounds the issue of track gauge, not electrical systems. Whereas the rapid transit loop trains were to be powered by a standard third rail, the interurbans were to be powered by overhead trolley wire. A few conceptual drawings of the Rapid Transit Loop's surface grading and concrete trestle above Columbia Avenue show provision for trolley poles.

No discussion of the inevitable one- or two-wire issue survives; obviously the interurbans could have operated entirely independently with a two-wire system. Since the broad gauge lines already had two-pole cars in order to travel over The Cincinnati Traction Company's tracks, this made the most sense, and might have been the plan.

Frequently Asked Questions

Unfortunately some of the equipment of the interurbans threatened to interfere with the Rapid Transit Loop's electrified third rail. Specifically, the interurban cars of the Indianapolis and Cincinnati Traction Company used a shoe to trip signals that would have conflicted with the loop's electric third rail.

When the various interurbans went out of business, were their tracks immediately disposed of?

No. The bankruptcy of the interurbans helped the cause of those desirous to kill the Rapid Transit Loop project, but in several instances their tracks were purchased by the Cincinnati Street Railway. Streetcar service took the place of interurbans and continued into the late 1930s on several lines and in the case of the CM&B until 1942. After their takeover by the Cincinnati Street Railway, passengers no longer had to transfer and pay two fares, and so service was significantly improved.

Were blueprints drawn for The Walnut Street Tunnel?

Preliminary engineering work was performed in 1916 and 1917. This included analysis of soil conditions and a request for blueprints of all buildings along the street. If final drawings were made, they do not survive today.

Where does above-ground right of way survive?

All overpasses and underpasses have been bulldozed, and much of the right-of-way has been taken by Interstate 75 and The Norwood Lateral, but the route of the Rapid Transit Loop can still be seen in some areas.

Between Hopple Street and Ludlow Avenue, the route can be traced for nearly 4,000 feet between I-75 and Central Parkway. The graded right of way is fully intact for 1,000 feet north of Workhouse Drive; north of that point it is occupied by an office building, its parking lot, and a remote parking lot for Cincinnati State Community College.

In St. Bernard, two significant stretches survive where I-75 deviates significantly from the path of the Miami-Erie Canal. A 2,500 foot section

can be traced east of Vine Street, and a shorter section of about 800 feet can be traced on City Park Drive.

In Bond Hill, the right-of-way can be traced between Reading Road and Section Avenue by the curving north edge of the former Showcase Cinemas parking lot.

In Norwood, 1,500 feet of right of way can be traced between the Montgomery Road overpass and the filled Harris Avenue tunnel.

Although no work was undertaken on the railway east of Norwood Waterworks Park, the general path of purchased right-of-way can be traced by driving along Enyart Avenue parallel to the B&O mainline. At Verne Avenue, a sharply angled building marks the odd-shaped property lines created by the right-of-way where it diverged from Enyart Avenue.

ABOUT THE AUTHOR

Jacob Mecklenborg is a Cincinnati native and a graduate of St. Xavier High School, the University of Tennessee and Ohio University. He has worked as a photojournalist, a graphic designer, a teacher, and as a towboat deckhand. More information on the subway project and contact information are posted on his website, www.jakemecklenborg.com.

Visit us at
www.historypress.net